draw animals in nature
with Lee Hammond

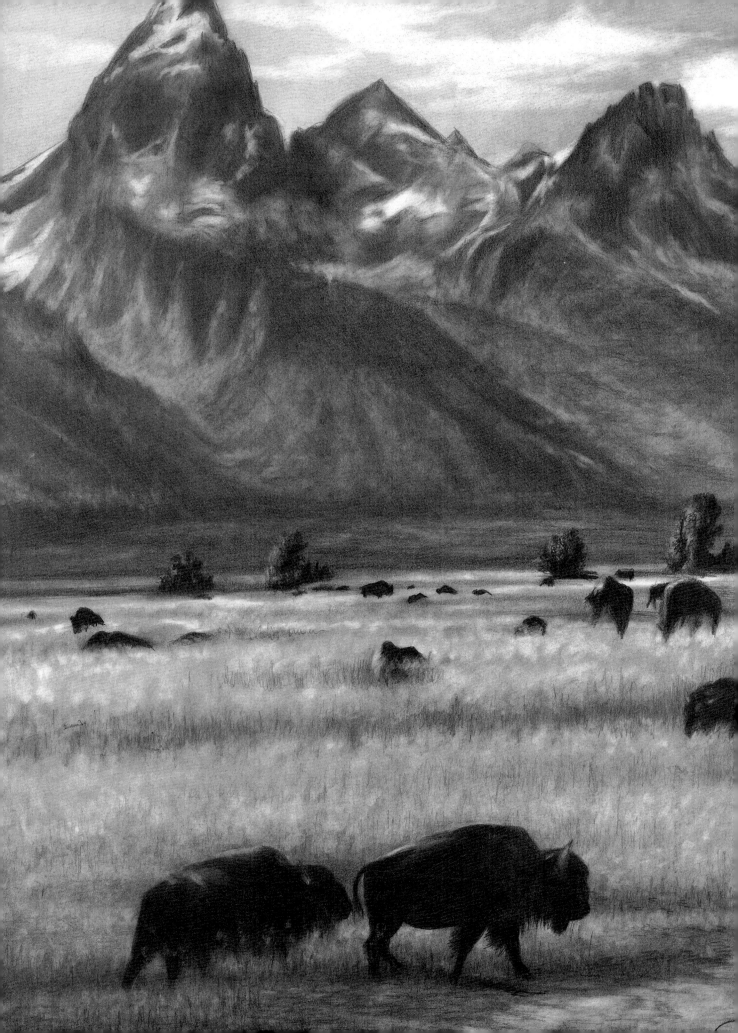

draw animals
in nature

with Lee Hammond

NORTH
LIGHT
BOOKS

Cincinnati, Ohio
www.artistsnetwork.com

Contents

Introduction

I have actually lost track of the number of art instruction books I have written over the past fifteen years. While I have written books on how to draw animals and books on how to draw landscapes, this is the first time I have combined the two for creating complete nature studies.

In this book you will learn how to create an entire scene using my blended pencil technique. Please study the lessons in the order in which they are presented and complete each of the demonstration exercises. If you do this, you will achieve a greater success in your artistic growth.

I am a firm believer in learning through practice and trial and error. It takes time to develop a skill, and you must be diligent. It's no different than learning a new language or a musical instrument. It may feel clumsy at first, but it will get easier and easier with practice. Be easy on yourself and just enjoy the process. I always say, "It is all in the doing!" It is the process that gives us the satisfaction. Just enjoy!

PANTHER
Graphite on smooth bristol
12" × 9" (30cm × 23cm)
(For information on helping to save panthers,
visit www.floridapanther.org.)

You Can Do It!

One of the most common concerns I have heard throughout my years of teaching is, "I can't even draw a straight line with a ruler! There is no way I can do this." Well, to that I say, "Yes you can!" The following examples are drawings done by students who were new to my methods and had little art experience before coming into my class.

Their first attempts reflect some common mistakes made by most beginners. For example, shapes are a bit distorted because no measuring methods were used. The students had previously believed that freehanding was the only way to draw like a real artist. The drawings are also over-outlined and a bit cartoon-like. There is a lack of dimension and realism due to not understanding my blended pencil technique.

The students' second attempts at drawing the subjects show the vast improvements made within just a couple of weeks of training. There is clear improvement in both the shapes and the rendering. To help them with their shapes, I explained the process of graphing using the grid system. If their subject was difficult with a lot of detail, I also allowed them to use a projector to capture their shapes on paper.

Before I let them jump in and start the details, I made all of them practice the techniques we will cover in this book. These techniques are critical to drawing realistically. In practicing them, you will see how quickly your art will improve.

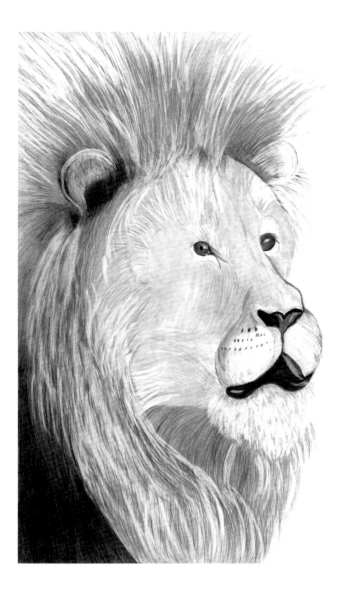

LEE'S LESSONS

Using a projector is not cheating! It is a smart way to capture an accurate line drawing, which is the foundation for your work. The rendering of the subject is what makes it art. Even the Old Masters used forms of projection to get the shapes correct before they began painting. Rulers, grids and projectors are all smart tools for achieving accuracy in your artwork.

Before

In her first attempt Chrissie struggled with the shapes. The slight turn in the lion's pose created some distortion in her initial line drawing. In creating the look of long hair, she stopped too soon. The results look incomplete.

Receive free downloads when you sign up for our free newsletter at artistsnetwork.com/newsletters_thanks.

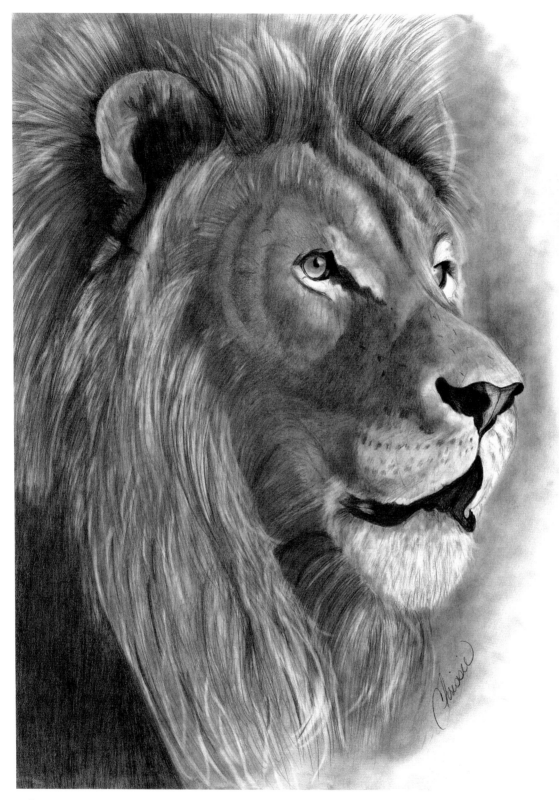

After

Using a projector helped to draw the proportions of the face accurately. Adding background tones behind the face makes the light look like it is reflecting off the lion. The fur looks thicker and more dimensional due to layers of pencil strokes and blending. The use of a kneaded eraser makes the fur look full and shiny. Chrissie said, "I never thought to add darkness around my drawing to make it stand out. It really helps make it look better. I was also surprised to see how many layers it takes to create the look of long hair."

ARTWORK BY CHRISSIE LEANDER

Get a bonus demonstration from *Amazing Crayon Drawing with Lee Hammond* at artistsnetwork.com/drawanimalsinnature.

9

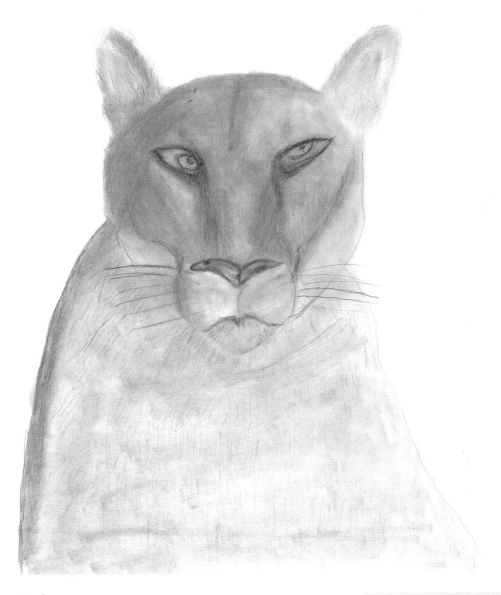

Before

In this attempt, the shapes are a bit cartoon-like. While Randy did try to use some blending, the drawing still lacks realism.

LEE'S LESSONS

The phrase I use the most when teaching is "Get it darker!" Some students swear they hear it in their sleep now. Contrast and the use of tones give a drawing believable dimensions. Without tone and contrast, the drawing appears flat and unfinished.

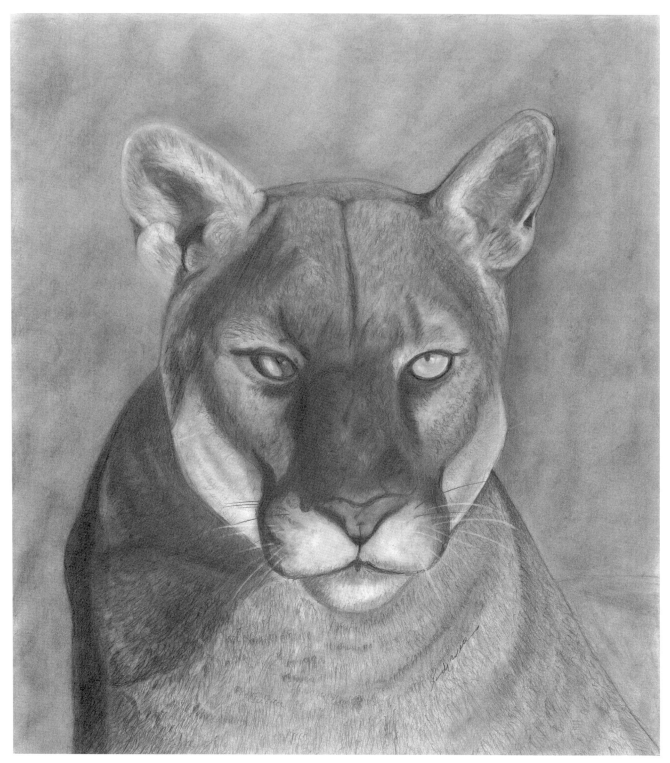

After

ARTWORK BY RANDY WILLIAMS

Everything about this drawing has improved. A projector helped to get the proportions correct, but the real improvement was in the blending technique and use of tone. Deepening the tones for more darkness brought out the contours of the panther's shape. A kneaded eraser helped create light areas to make the panther come to life. Randy said, "I learned so much from this exercise. Shapes are really important, but the shading is critical. It is all about getting it darker, and knowing where to put the lights and darks."

Get a bonus demonstration from *Amazing Crayon Drawing with Lee Hammond* at artistsnetwork.com/drawanimalsinnature.

11

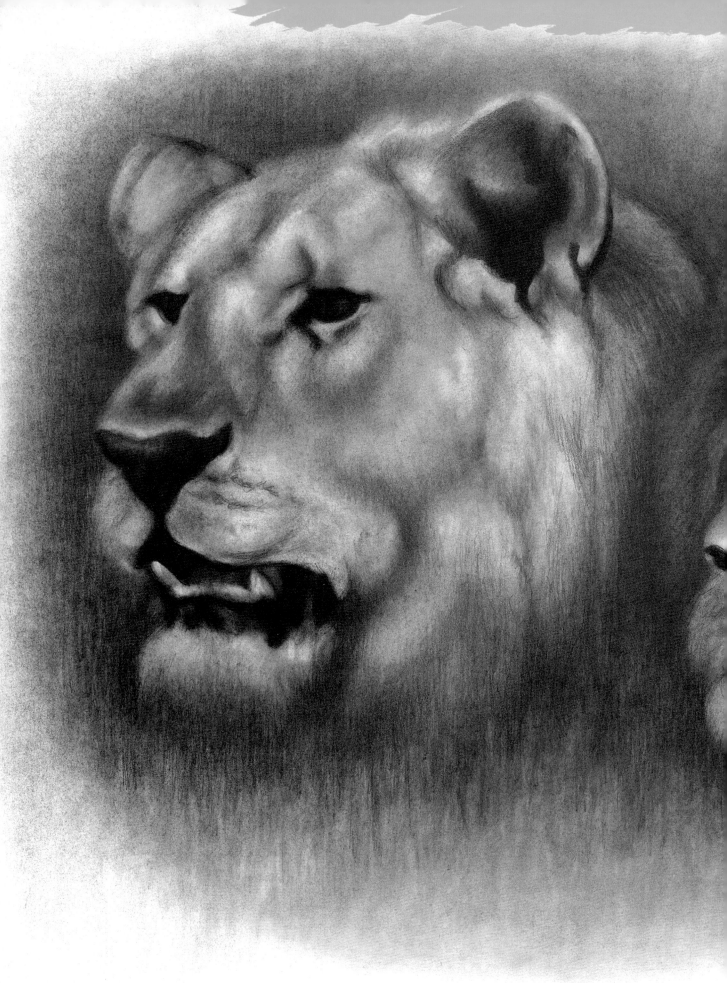

Materials & Techniques

I am a self-taught artist. I had a natural style to my drawing for as long as I can remember. I loved realism. Most of the time in school everyone else was doing just the opposite. When I was learning, self-expression and Impressionism ruled the art world. Abstract and loose drawing styles were the norm. I felt like I didn't belong. Fact is, I didn't.

I admired the works of Rembrandt and Michelangelo. I liked subtle shading and a smooth approach. Unfortunately, there was no one who could teach me those techniques. So the long, hard road of trial and error ensued. It took me years of practice to find the methods to create the look I wanted.

The following pages will reveal my secrets—secrets that took me years to develop and hone. We will cover the basics for drawing: shapes, contrast, form and blending. Even though it may seem a bit boring, these basic instructions are what separate the amateurs from the pros. Go slowly and really absorb the information. Before long, you too will be drawing realistically.

LIONS
Graphite on smooth bristol
9" × 12" (23cm × 30cm)

Materials

To create a quality drawing in graphite, you must have the right materials. Some blame themselves for being untalented when their work is subpar, but it is often the tools they are using. Using the right supplies makes all the difference. The following tools will help you achieve the right look in your drawings.

- **Smooth Bristol 2-Ply Paper**
 This paper is key to the Hammond Blended Pencil Technique. The plate finish is extremely smooth. It allows the graphite to blend evenly for a polished look. It also is very durable and will withstand the rubbing and erasing of this technique. This paper comes in various grades. For my professional work, I use the 500 series, 100% cotton paper in a 4-ply from Strathmore.

- **Drawing Board**
 It is very important to always tilt your artwork toward you as you draw. This prevents distortion. You can adhere your work to the board with tape or a clip.

- **Mechanical Pencil**
 Many ask me how many pencils I really use to create all of the subtle tones in my drawings. The answer is: one. I always use a .5mm mechanical pencil with 2B lead. Most mechanical pencils come loaded with a few sticks of HB lead. This lead, however, is too hard for the techniques I use in creating tone.

- **Blending Tools**
 For the smooth look of my drawings, I use tortillions and blending stumps. A tortillion is a piece of paper that is spiral-wound into a cone. I use these in small, detailed areas. For larger areas, such as backgrounds, I use a blending stump. This is a tool made of compressed paper and pressed into a pencil shape.

- **Tuff Stuff Eraser**
 This vinyl eraser has a small tip that operates like a mechanical pencil. The vinyl is easy on the paper and allows you to get a cleanly erased mark without any damage. I use it to create defined edges and bright spots of light.

- **Pink Pearl or White Vinyl Eraser**
 These larger erasers are good for cleaning larger areas of your work without paper damage.

- **Kneaded Eraser**
 This eraser is my favorite tool. Similar to the consistency of modeling clay, it can be pulled and stretched into shapes. I squish it into a point to lift small highlights. The softness of the eraser does not damage the paper surface. Kneading it like bread keeps the eraser clean.

Horsehair Drafting Brush

- **Horsehair Drafting Brush**
 When erasing, you can ruin your work by blowing away debris because you can accidentally spit. Then wiping away the erasings with your hand can smear your work. A drafting brush is soft and will clean the surface without damage. Never draw without one!

- **Rulers**
 Rulers help measure and graph your drawings.

- **Workable Fixative Spray**
 This is a spray used to seal and protect your artwork when it is finished. *Workable* means you can spray an area and then continue building up the dark areas in multiple layers. I seldom do this though, since I think it changes the smoothness of the paper. I use it after I am completely finished.

- **Acetate Grids**
 These handy overlays can help you draw shapes by dividing the subject into puzzle-like pieces. These grids can be created on a computer and then printed on acetate, or you can make one by hand. Take a clear report cover like we all used in school, and draw one-inch (25mm) grid lines on it with a permanent marker and a ruler.

- **Reference Photos**
 Good references are valuable sources for practice. I collect and categorize photos and magazine pictures. A word of warning, however: the photographers and magazines hold the copyright for these. Don't copy them exactly. Reproducing them in their entirety is prohibited by law without the written consent of the photographer or publisher. Use your own photos whenever possible.

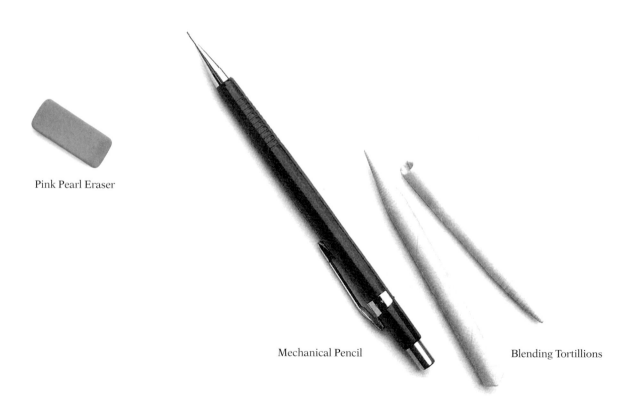

Pink Pearl Eraser

Mechanical Pencil

Blending Tortillions

Five Elements of Shading

In order to achieve realistic drawings, you must be able to draw three-dimensional forms and understand how light affects those forms. Five elements of shading appear in every three-dimensional shape (demonstrated here with a sphere). Practice creating these different tones. Once you've mastered them, you can draw just about anything.

1 **Cast shadow.** This is the darkest part of your drawing. It is underneath the sphere, where no light can reach.
2 **Shadow edge.** This is where the sphere curves and the rounded surface moves away from the light.
3 **Halftone.** This is the true color of the sphere, unaffected by either shadow or strong light.
4 **Reflected light.** This is the light edge along the rim of the sphere that illustrates the roundness of the surface.
5 **Full light.** This is where the light is hitting the sphere at its strongest point.

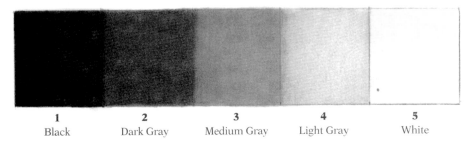

1	2	3	4	5
Black	Dark Gray	Medium Gray	Light Gray	White

Practice Blending Tones

Before you begin drawing actual objects, I recommend that you first draw some blended-tone swatches, as shown on the value scale, to help you learn to control your blending. Start with your darkest tone on one side and gradually lighten the tone as you continue to the other side. Do as many as you need to until you feel proficient at it.

Compare Tones in the Value Scale to Tones in the Sphere

Notice how the five elements of shading on this sphere correspond to the five tonal values on the scale above. The light is coming from the front, a little off to the right.

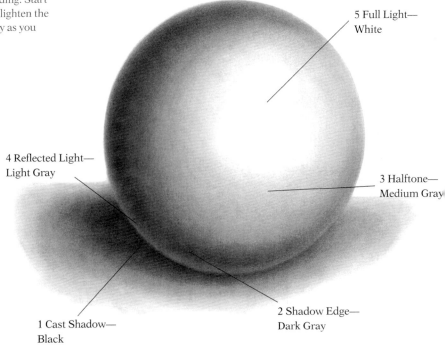

5 Full Light—
White

4 Reflected Light—
Light Gray

3 Halftone—
Medium Gray

1 Cast Shadow—
Black

2 Shadow Edge—
Dark Gray

Receive free downloads when you sign up for our free newsletter at artistsnetwork.com/newsletters_thanks.

Blending

Proper shading requires smooth blending. To create smooth blending, you must first learn to use your tools and apply the pencil lines properly. If the pencil lines are rough and uneven, no amount of blending will smooth them out.

Apply your pencil lines softly and always in the same direction. Build your tones slowly and evenly. Gradually lighten your touch as your transition into lighter areas. Smooth everything out with a blending tortillion, moving in the same direction you used to place your pencil tone. Begin with the darks and blend out to light.

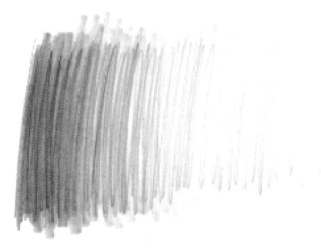

Incorrect Blending

This example shows poor pencil application. The scribbled lines look sloppy, and a tortillion wasn't used for blending.

Hold Your Tortillion at an Angle

For even blending and to keep the end of your tortillion sharp, always hold it at an angle. If the end becomes blunt, poke a straightened paper clip through the top to straighten it out.

Correct Blending

Apply the lines closely. Then, in an up-and-down fashion, fill them in. Add tone until you build up a deep black, then lighten your touch and gradually get lighter as you move to the right. Blend your values with a tortillion using the same up-and-down motion you used with the pencil. You do not want to see clear distinctions between where one tone ends and the next begins. Lighten your touch as you move right and gently blend the light area into the white of the paper until you can no longer tell where it ends.

Get a bonus demonstration from *Amazing Crayon Drawing with Lee Hammond* at artistsnetwork.com/drawanimalsinnature.

17

Applying Principles

Once you begin to draw actual objects, such as the cylinder shown below, use the following guidelines to help you.

1 **Soft edge.** This is where the object gently curves and creates a shadow edge. It is not harsh, but a gradual change of tone.
2 **Hard edge.** This is where two surfaces touch or overlap, creating a harder-edged, more defined appearance. I do not mean outlined! Be sure to let the difference in tones create the edge.
3 **Application of tone.** Always apply your tones, whether with your pencil or tortillion, with the contours of the object. Follow the curves of the object, with the shading parallel to the edges so you can blend into the edge and out toward the light. It is impossible to control blending if you are cross-blending and not following the natural edges and curves.
4 **Contrast.** Don't be afraid of good solid contrasts of tone. Always compare everything to black or white. Use your five-box value scale to see where the gray tones fit in. Squinting your eyes while looking at your subject matter obscures details and helps you see the contrasts better.

The sphere, cone and cylinder are all important shapes to understand if you want to draw animals in nature. If you can master the five elements of shading on these simple objects first, drawing the animals in their natural settings will be much easier.

ADDITIONAL HELPFUL HINTS

- Correct uneven tone by forming a point with your kneaded eraser, then drawing in reverse. Use a light touch and gently remove any areas that stand out as darker than others. Fill in light spots lightly with your pencil.
- Spray areas that need to be extremely dark with fixative, and build up darks in layers. Be sure to finish any erasing that needs to be done before spraying.
- Use your kneaded eraser to crisp up edges and remove any overblending.

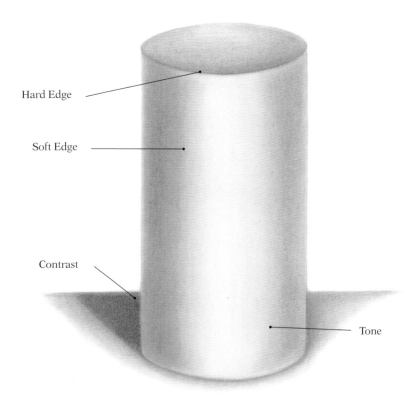

Hard Edge

Soft Edge

Contrast

Tone

Receive free downloads when you sign up for our free newsletter at artistsnetwork.com/newsletters_thanks.

Learn to See Basic Shapes

All subjects, no matter how complex, consist of underlying basic shapes. Learn to recognize these basic shapes, and you will be able to draw anything by applying the five elements of shading.

LEE'S LESSONS

Use your Tuff Stuff eraser to crisp up any edges and remove any overblending.

Sphere

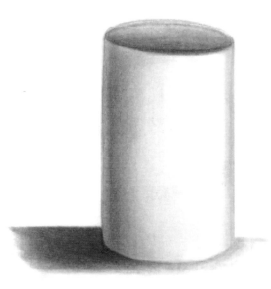

Cylinder

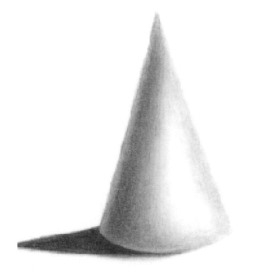

Cone

Finding Basic Shapes in Nature

Look at the rough sketch and the finished illustration of the rhino. Identify the basic shapes as they relate to anatomy. The cone shapes appear in the horns and ears. The sphere is in the head, nose and jaw. The cylinder is in the overall face shape and neck.

Identifying these basic shapes before you begin to draw will help you be more accurate in your work. In the finished piece, you can also see how the Hammond Blended Pencil Technique creates realism in the drawing.

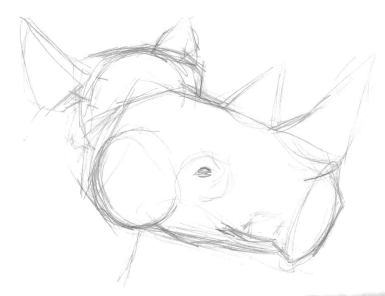

Identify the Basic Shapes
Seeing the basic shapes in the animal helps you draw it more accurately.

Shading Creates Realism
The five elements of shading and my blending technique make the basic shapes of the rhino's face look realistic.

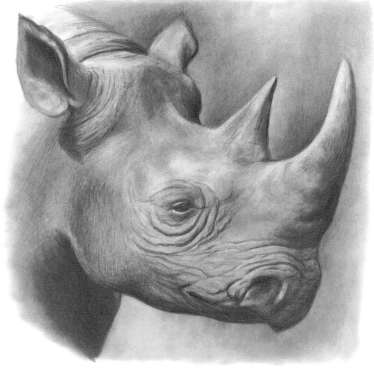

Receive free downloads when you sign up for our free newsletter at artistsnetwork.com/newsletters_thanks.

Creating Light

As children we are taught to draw everything in line form, much like a cartoon or coloring book. Everything is outlined on white paper with no background. Even when I was a child using a coloring book, the realist in me made me want to fill in the background with color as well.

Background tones are critical for the look of realism. Without them, you have no depth. Study the sphere below and see how the dark tone of the background makes the lighter edges of the sphere stand out. Let your dark create your light!

This rule applies to all subjects, whether they are simple like the sphere or complex like the illustrations that will follow in this book.

REFLECTED LIGHT

Reflected light is always seen on objects along the edge, lip or rim. Look at any object around you now, and you can see the light. As I type these words on my computer, I see light along the edge of my screen and along every key. Looking at the table, I see it on the edge. As I type, light is reflecting off the edges of my fingers. Look around you and observe. Observation is the key to learning.

LIFTING REFLECTED LIGHT

In this book I will be referring to "lifting light" over and over again. This is done with a kneaded eraser. But do not think of this as erasing. Erasing implies making a mistake and getting rid of it completely. Lifting is the gentle process of removing just enough darkness to create a highlight effect. It is like drawing in reverse.

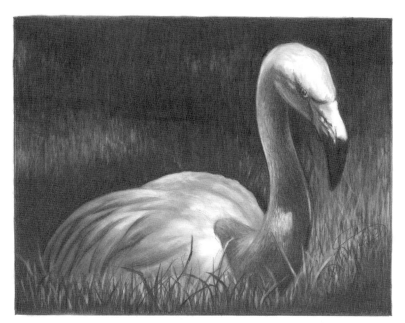

The Effects of Light

Study this drawing of a flamingo for the effects of light. Notice how reflected light has created the look of roundness and form on the flamingo, making it look real. Without the extreme lighting situation, the drawing would not be nearly as dramatic.

> **LEE'S LESSONS**
>
> *Always keep the light source in mind as you draw. It is imperative that you know where the light is coming from!*

DRAW A SPHERE AND EGG

Add background tones to basic shapes to create the realism found in nature. Follow along to create the sphere and the egg. I used a border around each drawing to make it simpler.

You will follow the same set of steps to create both objects. The only difference is that the egg must be drawn freehand.

Materials

.5mm mechanical
pencil with 2B lead
kneaded eraser
ruler
smooth bristol paper
tortillion

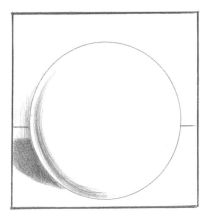
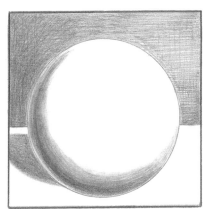
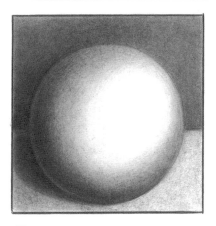

1 Draw the Circle

With a ruler, draw a perfect square on your paper. The size is up to you. Using a template or object, draw a circle towards the bottom of the square. With your ruler, create a line to represent a tabletop behind the sphere. Add the cast shadow to the darkest area (below the sphere). It does not go up as far as the table line. Add the shadow edge to the left side. Be sure the reflected light shows along the edge of the sphere.

2 Add Tone

Add tone behind the sphere with your pencil. The background is darker on the left side. You can see how the darkness here creates the light edge of the shape. Remember, let your dark create the light! Deepen the tones of the shadow edge allowing it to get lighter as it moves up. Be sure to follow the curve of the shape to continue creating the form.

3 Blend to Finish

Use blending to finish the sphere. Start with the background tone. Blend, then deepen it with your pencil again and blend once more. Add some light tone to the table with your pencil and blend. Allow the cast shadow to soften into it. Deepen the tone of the cast shadow after blending. Look at how the reflected light shows along the sphere's edge. Allow the tones to fade into the full light area in the middle right side.

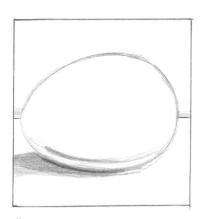
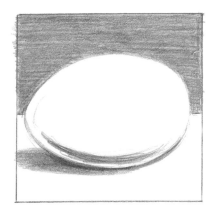
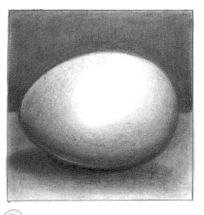

1 Draw the Egg

2 Add Tone

3 Blend to Finish

DRAW A CYLINDER AND CONE

The cylinder is a very important shape when drawing nature. It appears in many things such as tree trunks and the arms, legs and necks of many animals. Cone shapes are seen in animals' faces and ears.

Materials

.5mm mechanical
 pencil with 2B lead

kneaded eraser

ruler

smooth bristol paper

tortillion

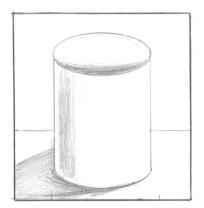

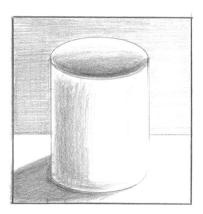

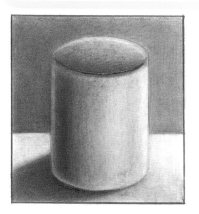

1 Draw the Cylinder
Create an ellipse. Use the same curve to create the bottom of the cylinder. Use a ruler to connect the top and bottom with vertical lines. Create the table edge. Add the cast shadow to the left of the cylinder. Make it darkest at the edge of the cylinder. Add the shadow edge with vertical pencil strokes. Allow a light edge to appear on the side.

2 Add Tone
Add some tone to the top of the cylinder along the front edge. Add tone behind the cylinder with your pencil. It is darker on the left side. Deepen the tones of the shadow edge, allowing them to get lighter as they move into the center. Be sure to use vertical strokes.

3 Blend to Finish
Use blending to finish the cylinder. Start with the background tone. Use the same procedure to finish as you used for the sphere and egg.

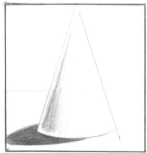

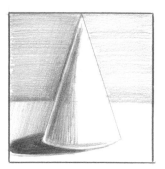

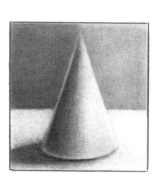

1 Draw the Cone
The tip of the cone should be in the middle of the square. Each side of the bottom is the same distance from the edge of the square border with the lines drawn down from the top point. The curve at the bottom is an ellipse, like the bottom of the cylinder above.

2 Add Tone
Use the same procedure to add tone as you used when drawing the sphere and the egg.

3 Blend to Finish
Use the same procedure to finish as you used for the sphere and the egg.

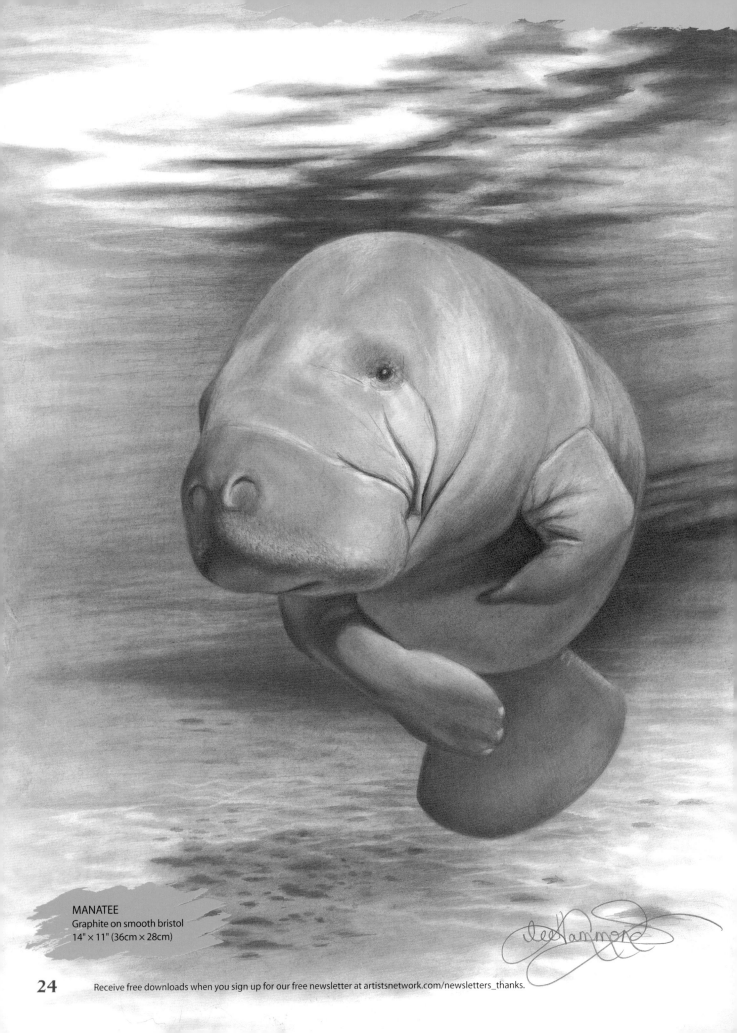

MANATEE
Graphite on smooth bristol
14" × 11" (36cm × 28cm)

Receive free downloads when you sign up for our free newsletter at artistsnetwork.com/newsletters_thanks.

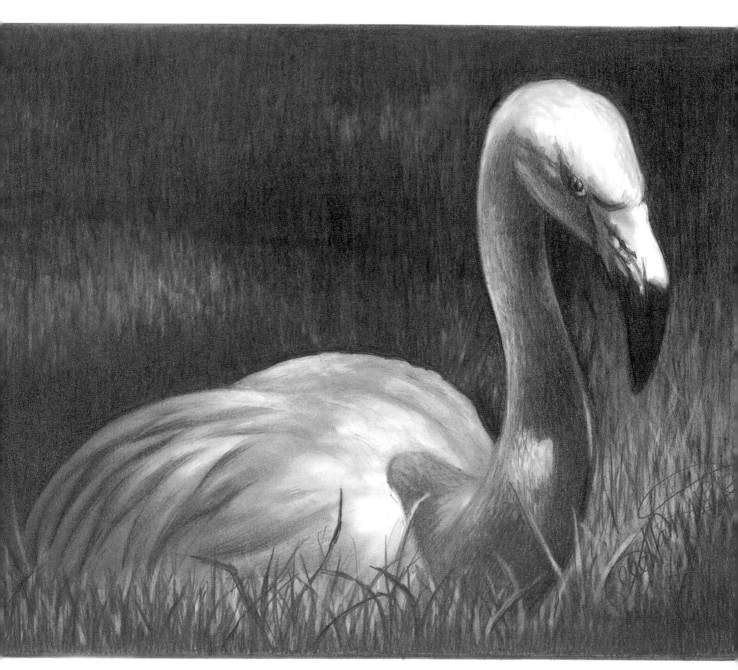

Shapes Make Form

You can see in these drawings the importance of understanding basic shapes, like the sphere and the egg, along with the five elements of shading when it comes to drawing animals. Applying these elements to your work makes all the difference between a simple line drawing and true realism.

FLAMINGO
Graphite on smooth bristol
7" × 9" (18cm × 23cm)

The Puzzle Piece Theory

Before you begin any type of blending on your artwork, it is important to give yourself a firm foundation to build on. To do this, you need an accurate line drawing.

The easiest and most educational way to draw from photos is to use a graph. A graph is a tool that divides your subject into smaller workable boxes to draw in. This exercise will help you understand how a graph works. It's fun, too, just like a puzzle!

Here we have a series of numbered boxes containing black-and-white nonsense shapes. Draw these shapes in the corresponding numbered boxes in the empty graph on the next page. You'll learn to *see* shapes this way.

Do not try to figure out the subject you are drawing. Once we become aware of what the subject matter is, we tend to draw from our memory instead of drawing what is right in front of us.

No matter what you are drawing, concentrate on seeing the subject as many individual shapes, which interlock like a puzzle. If one of the shapes you're drawing doesn't lead to the next one, fitting smoothly together, you'll know that your drawing is inaccurate.

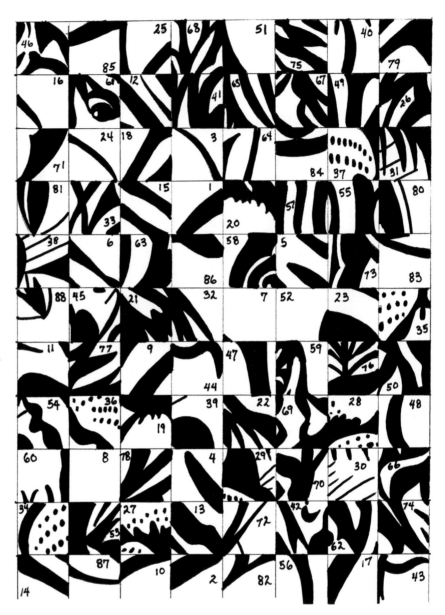

See All Subject Matter As Shapes

Look for the interlocking shapes within the tones and shapes of the object you are drawing. This exercise will show you how well you can draw, without even knowing what it is you are drawing!

1	2	3	4	5	6	7	8
9	10	11	12	13	14	15	16
17	18	19	20	21	22	23	24
25	26	27	28	29	30	31	32
33	34	35	36	37	38	39	40
41	42	43	44	45	46	47	48
49	50	51	52	53	54	55	56
57	58	59	60	61	62	63	64
65	66	67	68	69	70	71	72
73	74	75	76	77	78	79	80
81	82	83	84	85	86	87	88

Solve the Puzzle

Make a copy of the empty graph, then draw the nonsense shapes exactly as you see them on the previous page. Be sure to draw each shape in its corresponding numbered box.

Get a bonus demonstration from *Amazing Crayon Drawing with Lee Hammond* at artistsnetwork.com/drawanimalsinnature.

27

The Grid Method

Everything you draw can be done more accurately if you look at your subject matter as a group of interlocking abstract shapes. Placing a grid over your reference photos can help you see things more objectively by dividing everything into small sections. The squares will help you see your subject matter like a puzzle. You can further your objectivity by turning the photo upside down.

There are two different ways to grid your reference photos. The first way is to have a color copy made of your photo. If the photo is small, enlarge it. Working from small photos is the biggest mistake most students make. The bigger the photo, the easier it is to work from.

Use a ruler to apply a 1-inch (25mm) or ½-inch (13mm) grid directly onto the copy with a permanent marker. Use the smaller grid if there is a lot of detail in your photo. There is less room for error in the smaller box, so little things are captured more easily.

If you don't have access to a copier and your photo is large enough to work from, place a grid overlay on top of the photo. Make your own grid with a clear plastic report cover and a permanent marker, or have one printed from a computer on an acetate sheet.

Once you place the grid over the photo, the image becomes a puzzle and each box contains shapes. Look at everything you want to draw as a bunch of interlocking shapes.

Draw a grid on your drawing paper with a mechanical pencil. Draw the lines so light you can barely see them. You will have to erase them later. This grid should contain the same size and number of boxes as the grid over the photo.

Enlarge the size of your drawing by placing the smaller grid on your reference photo and making the squares larger on your drawing paper. For instance, if you use the ½-inch (13mm) grid on the photo and a 1-inch (25mm) grid on your paper, the image will double in size. Reduce the size of the drawing by reversing the process. As long as you are working in perfectly square increments, the shapes within the boxes will be relative.

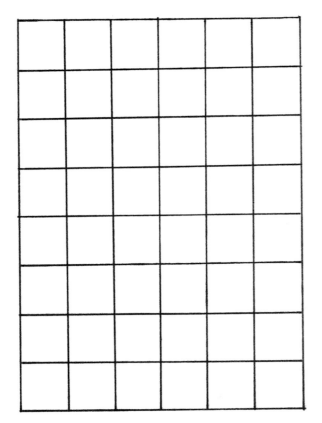

½-Inch (13mm) Grid

1-Inch (25mm) Grid

Receive free downloads when you sign up for our free newsletter at artistsnetwork.com/newsletters_thanks.

Create a Line Drawing With a Grid

Using the grid method of drawing will help you create accuracy in your shapes. It is no different than the puzzle we did previously except now we know what the subject is. Unfortunately, that is exactly what will make it hard.

We have a tendency to draw from memory instead of seeing things as little shapes that interlock. Try to always draw what you see, not what you think you know. Use the grid as a way to divide what you know into small shapes within each box. Drawing only the shapes you see within each box will help you be accurate.

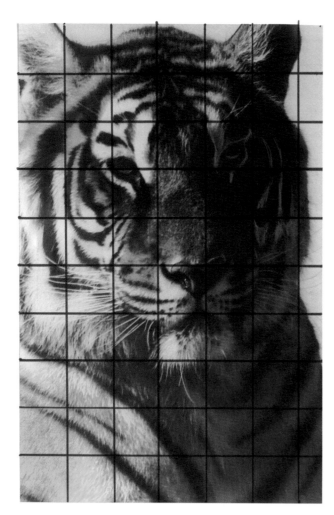

Create a Grid on Your Paper

Count the squares on the photo reference and draw the same number on your drawing paper using a very light touch. These lines need to be light and easy to erase later.

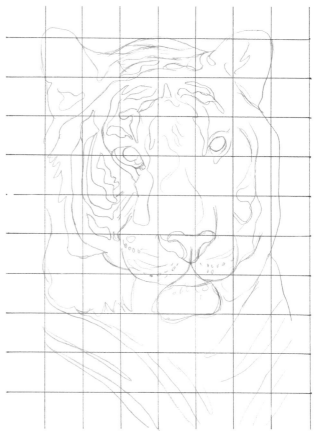

Fill in the Shapes

Drawing just one box at a time, capture the shapes of the tiger as seen within each box from the reference photo. Go slow and see the reference as a puzzle. The entire outcome of the drawing hinges on how accurate you are at this stage of the game.

Get a bonus demonstration from *Amazing Crayon Drawing with Lee Hammond* at artistsnetwork.com/drawanimalsinnature.

29

PRACTICE A SEGMENT DRAWING

Segment drawing is my favorite way to teach a student how to draw. It is a simple technique for seeing things in a smaller, more isolated way. It helps you gain valuable practice without becoming overwhelmed by creating an entire project.

By using a small viewfinder, you can break a reference down into an abstract perspective. It helps you to concentrate on shapes and gives you a small area to practice the five elements of shading.

Materials

.5mm mechanical
 pencil with 2B lead

kneaded eraser

ruler

smooth bristol paper

tortillion

1 Create the Viewfinder
Cut an opening into a black piece of paper using a ruler and a craft knife. Make the opening two inches (51mm) square.

2 Place the Viewfinder Over the Reference Photo
Place the viewfinder over your photo so just a portion is revealed. This changes the photo into a collection of smaller shapes. This small segment will be what you draw.

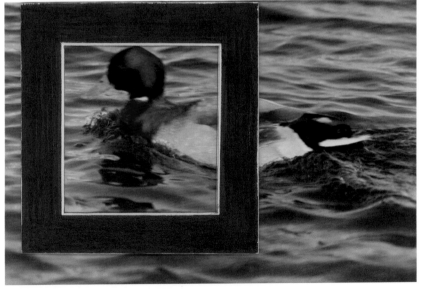

3 Create the Line Drawing

Draw the same two-inch (51mm) box on your drawing paper. Lightly and carefully draw the shapes you see within your viewfinder photo. If you need to, divide the square into four boxes and use the grid method.

4 Fill In Darks First

Always let the dark create the light. Fill in the darkest areas of the drawing first. In this photo, the darkest areas are in the head of the duck and the reflections in the water.

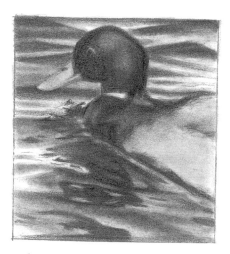

5 Deepen the Darks

Deepen the dark areas with more pressure on your pencil so it fills in. Look carefully at the photograph to see the patterns. Remember to see them as puzzle piece shapes.

6 Finish

To finish the drawing, use a tortillion to blend the tones smooth. The blending will create the gray tones on the back of the duck and on the gray areas in the water. Reapply the dark areas for more contrast, and then use a kneaded eraser to lift the light. This makes the highlights on the water look more reflective.

LEE'S LESSONS

Observing the shapes within the viewfinder as puzzle pieces will help you achieve accuracy. Always start with the dark areas first and allow the darks to create the light.

Get a bonus demonstration from *Amazing Crayon Drawing with Lee Hammond* at artistsnetwork.com/drawanimalsinnature.

31

Create a Segment-Drawing Notebook

To gain valuable drawing experience, a notebook dedicated to segment drawings is perfect. Here is a page from mine. (Yes, I still practice every day!) Take a sketchbook and draw two-inch (51mm) squares on each page as shown. Use a viewfinder placed over magazine photos for practice, using a variety of subject matter. Each one will give you different challenges to work on. By doing one a day, you will improve your drawing skills exponentially.

To dress up the look of your drawings, draw a dark border around each one with a ruler or use decorative graphic tape, which can be purchased at an art supply store.

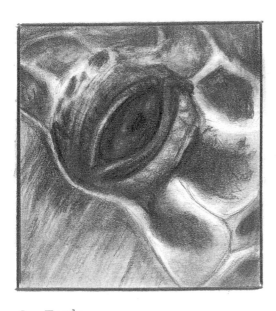

Sea Turtle
This is a close-up of a sea turtle. (Did I have you guessing?) Its unique collection of shapes, patterns and textures is perfect for segment drawing.

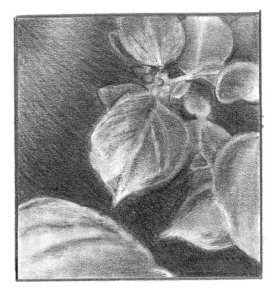

Leaf
This leaf study was a great refresher course on the effects of light and dark. Look at how the light is dancing off all the edges. Remember the rule about edges and rims: be sure to let the difference in tones create the edge.

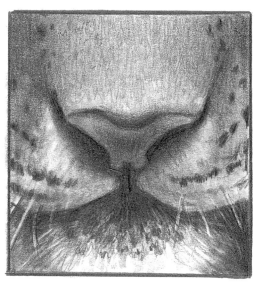

Tiger

This close-up helped me gain valuable information about cat noses and mouths. Drawing like this forces you to see details. Sometimes when we draw an entire subject, we forget to keep looking, and we draw in general, instead of in detail.

Ground Squirrel

Like the close-up of the tiger, this ground squirrel study helped me learn how to draw short fur and patterns.

Pond

All subject matter can be used for your segment drawing notebook. This portion of a pond had nice contrasts of light and dark to capture.

Landscapes

Landscapes can be learned by drawing small portions. This makes you concentrate on the patterns of light and dark, and how the textures need to be created.

Get a bonus demonstration from *Amazing Crayon Drawing with Lee Hammond* at artistsnetwork.com/drawanimalsinnature.

33

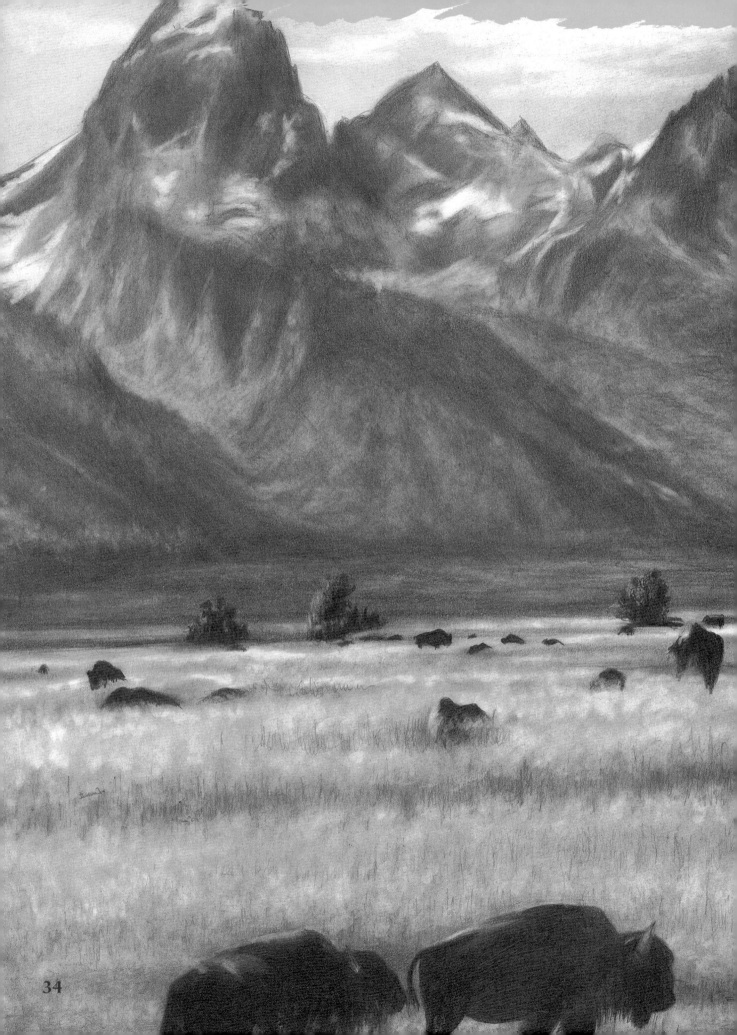

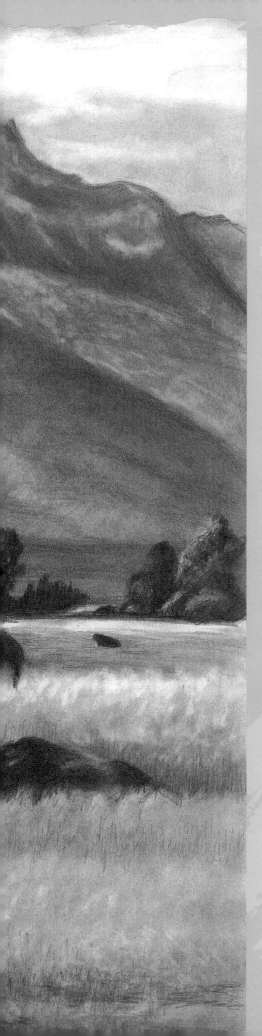

Nature

You're probably getting antsy to draw some animals, but it is very important to learn how to draw environments first. Having a good handle on this is essential to drawing animals in their natural surroundings. Without this knowledge, you will be reduced to drawing animals in portrait form with no natural setting involved.

Look at the finished drawing at the left. As you can see, it has the elements of an entire scene. It looks complete, much like a photograph. To create a drawing such as this, you must know how to create depth and the layers of atmosphere in scenery. The drawing of the mountains and buffalo can be divided into layers, going from back to front. The layers consist of:

- *The sky and the mountains (the background)*
- *The middle of the paper*
- *The horizon line (below the middle)*
- *The midground (distant ground)*
- *The foreground (close-up ground)*
- *The subject matter (buffalo)*

Most scenic drawings have at least four of the five elements listed above. This chapter will show you how to incorporate these elements into drawing scenery.

BUFFALO AT THE GRAND TETONS
Graphite on smooth bristol
11" × 14" (28cm × 36cm)

Composition

This diagram shows the buffalo drawing and how the landscape can be divided into layers. Keep this diagram in mind when drawing scenery to be sure you properly capture the depth.

The most important thing to recognize first is what is called a *horizon line*. This tells the viewer where eye level is. It generally is the dividing point between the ground and the sky, or in this case, the ground and the mountains.

It is very important to never place the horizon line right in the middle of the paper. Once the other elements are in, the balance will be off on your composition if it is divided in the middle. The horizon line on the buffalo drawing is below the center of the paper. This allows more room up top for the weight of the large mountain area.

I love this drawing for the way it leads your eye around the page. All of the layers have things to look at that add to the total picture.

I also like the amount of depth that has been created. When you look, you can see a clear depiction of distance. The buffalo in the foreground, the layer closest to the viewer, are much darker and more in focus.

The middle layers seem to be a bit lighter, and the mountains in the distance seem hazy and lighter in tone. The farther back an object is in the background, the more layers of atmosphere are between it and the foreground. This causes a hazy effect due to the atmosphere dulling the details.

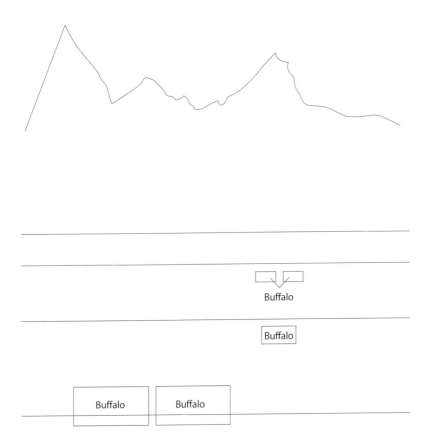

Elements of Composition

The foreground is the part closest to the viewer. The midground lies just beyond the foreground. The horizon line lies between the midground and the middle of the paper. And the sky and mountains make up the background.

Receive free downloads when you sign up for our free newsletter at artistsnetwork.com/newsletters_thanks.

Five Elements of Nature

The following segment drawings will give you practice with five of the most common elements of drawing nature. It is a good way to add to your segment drawing notebook as well.

Draw each one using the information from the segment drawing lesson. We will cover each element in more depth later.

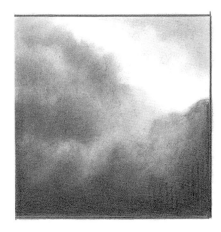

Skies

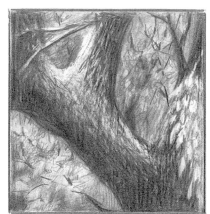

Trees

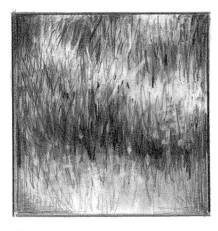

Grass

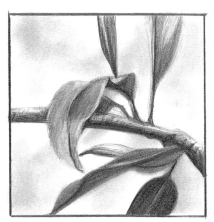

Leaves

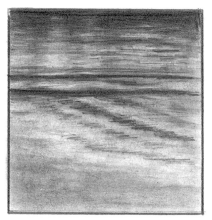

Water

Skies

It is important to learn things slowly before attempting a difficult scene all at once. When drawing nature, you should learn each element completely.

The segment drawings gave you some practice, but let's try more complete drawings now. Start with the sky. Never is blending more important than when drawing skies. It is important to capture the smoothness of the atmosphere.

While this drawing doesn't look like much, it is still an important one. Imagine how it would look with a tree or a wild animal in front of it. Sometimes the sky itself is the focal point. By combining a pretty subject with a dramatic sky, your art can double its beauty. Suddenly, this simple blended sky becomes a realistic backdrop, making your artwork look amazing.

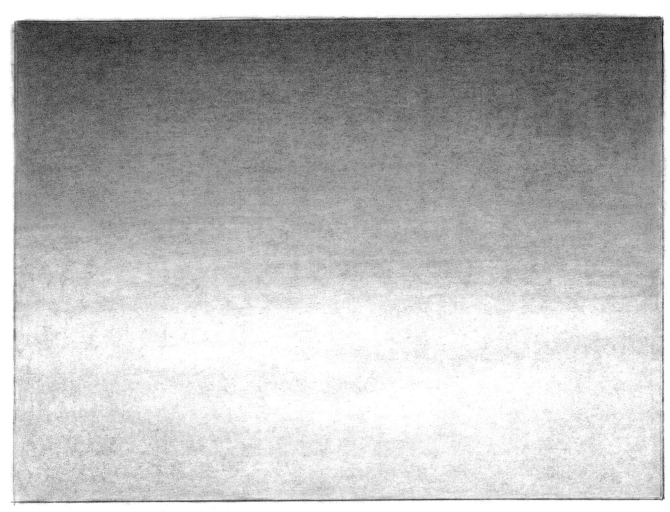

The Sky Is a Useful Background

A blended background such as this can be a key element in your wildlife art.

Receive free downloads when you sign up for our free newsletter at artistsnetwork.com/newsletters_thanks.

Clouds

Drawing skies can be fabulous. I take photos of sunsets and clouds all the time hoping for that perfect reference to draw from. This drawing was done from a photo I took during a quick storm. I was actually in my car driving to the beach to take photos knowing that the clouds were going to be gorgeous that day because of the storm. At a traffic light, I looked over and saw this cloud along the horizon. The little heart shape caught my eye, and I grabbed my camera. The suns rays radiating out from the heart were a perfect gift from nature.

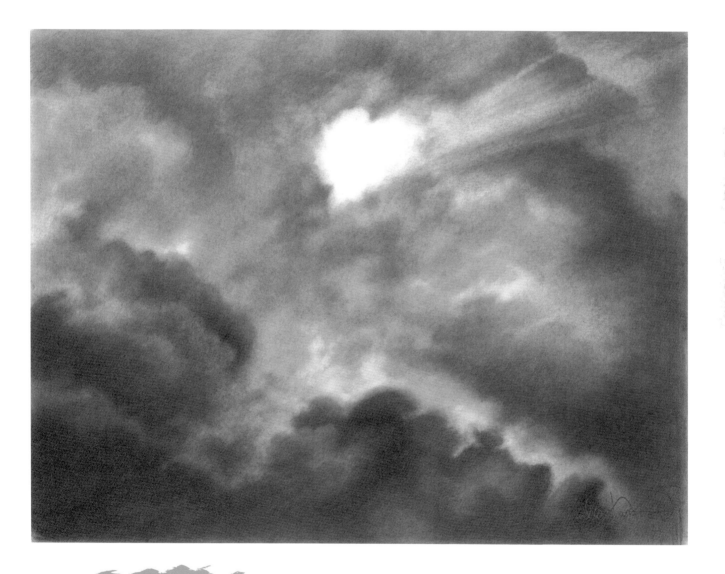

NATURE'S GIFT
Graphite on smooth bristol
8" × 10" (20cm × 25cm)

DRAW A SUNSET

This project will give you practice creating a sky scene that has a lot of appeal. Start by reviewing the finished drawing. It will give you a better understanding of what we are creating. It is a beautiful combination of light and dark created with blending and lifting. While it may look intense, it is not as complicated as you might think.

When drawing skies, remember that the atmosphere moves horizontally. When creating the patterns of sky in a drawing, you must apply the pencil lines horizontally to match this.

> ## Materials
>
> .5mm mechanical pencil with 2B lead
>
> kneaded eraser
>
> ruler
>
> smooth bristol paper
>
> tortillion

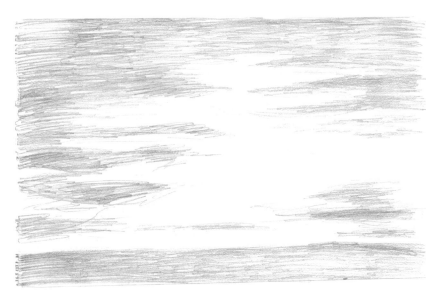

1 Apply Darkness and Pattern
Starting at the bottom, apply the darkness to the foreground area. This gives you the horizon line. Then move up to the sky area and apply the patterns with horizontal pencil strokes as shown.

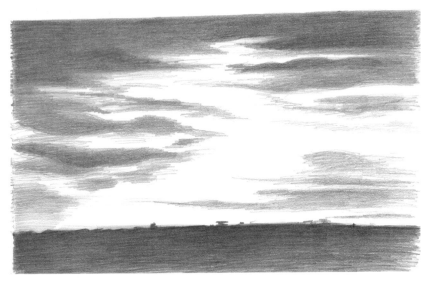

2 Deepen the Sky Patterns
Continue using the horizontal strokes to deepen the patterns. They need to be extremely dark, so use firm pressure on the pencil.

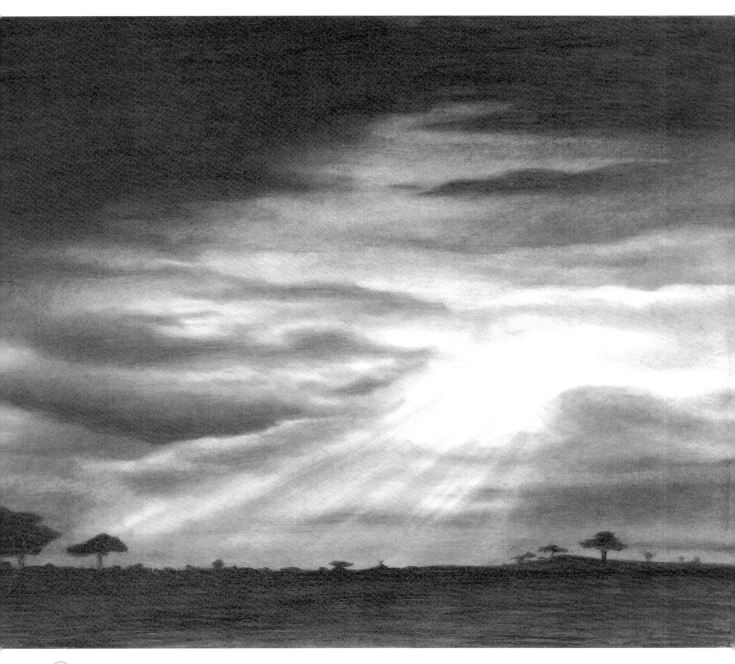

3 Blend to Finish

Use a stump to blend the drawing. A tortillion is too small and will not blend a large area such as this smoothly. A stump is much better for a project this size.

When blending tones with the stump, use the same horizontal strokes you did to apply the pencil. Blending sometimes will make things appear lighter, so reapply your pencil if necessary to keep the tones dark. You will need to blend again, but you can repeat this process as often as needed.

Even though there are areas of white in the drawing, it is important to lightly blend these areas to a light gray. Light always looks better when it's lifted instead of left out.

Once everything is blended, use the kneaded eraser to lift out the white areas. Using the horizontal strokes is important when lifting out the cloud areas and the lighter areas of the sky. Do the sun rays last, overlapping everything else. They should radiate outward, straight, like the spokes on a wheel.

When the sky is finished, add the small silhouettes of the trees in the foreground.

Trees

With many different types of trees in nature, the only way to depict them well is by practicing. Drawing all types of trees and plant life will give you better skills for drawing scenery. Each drawing will have different elements to capture. What I have offered so far are just suggestions, not hard-and-fast rules. Each drawing will be different according to the subject matter and the lighting affecting it. This drawing is a perfect example of breaking the traditional rules.

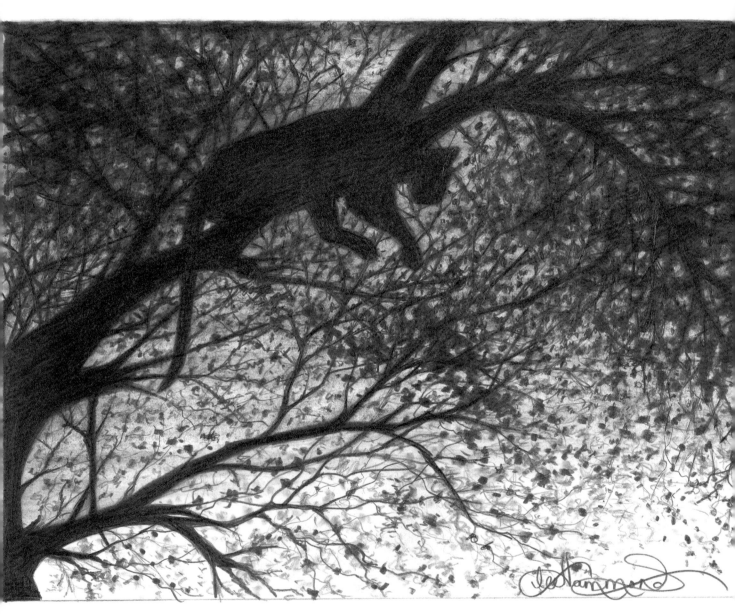

Blending Creates the Illusion of Layers

I used blending as a way of creating the illusion of layers in the tree. Creating gray tone behind the darkest tones and blurring out the shapes makes it appear as if there are multiple layers of leaves. The ones that are closest are larger. Their shapes are more distinct, and I made them as dark as I possibly could. If I had just placed black leaves upon white paper, the illusion of depth would be lost.

Because of the view, we do not have all of the layers usually seen in a landscape drawing. The elevated perspective reduces the layers you are seeing. Combined with extreme lighting, which makes the leopard and the tree appear as silhouettes, you now have only background and foreground images to deal with.

LEOPARD IN A TREE
Graphite on smooth bristol
7" × 10" (18cm × 25cm)

Receive free downloads when you sign up for our free newsletter at artistsnetwork.com/newsletters_thanks.

Simple Silhouettes

Silhouettes are common in landscape drawing and painting. Subjects in the foreground will appear as silhouettes due to backlighting in the distance.

Blending and Tone Help Create Depth

In this drawing the layers of atmosphere are very obvious. The blending in the sky gives the illusion of cloud layers and distance. The trees in the distance appear very small when compared to the ones in the front. They also appear lighter in tone, which is essential to creating the look of distance. When using tone to create depth, always work back to front as you develop the drawing. This is necessary since everything overlaps the sky.

DISTANT PINES
Graphite on smooth bristol
6" × 8" (15cm × 20cm)

Drawing Pine Trees

Pine trees have a distinct shape and are usually easier to draw because the overall shape is more evident and repetitive. The larger components become like puzzle pieces.

Start with the vertical line to represent the trunk. Create the repetitive shapes of the branches with squiggly lines. Continue building the tones with squiggly lines until you create the pine tree look.

Drawing Leafy Trees

Leafy trees generally have more limbs and small branches. They are less uniform in their shapes.

Start with a vertical line to represent the trunk. Place light lines for the branches. Use small, tight circular pencil strokes to start the look of leafy clumps. Continue building the illusion of leaves with the circular strokes, varying the tones. Use little dots, like stippling, for the smaller leaves on the outer edges.

DRAW A SILHOUETTE SCENE

Now it is time for you to draw a scenic silhouette of your own. Blending is the most important part of this drawing.

Materials

.5mm mechanical
 pencil with 2B lead

kneaded eraser

ruler

smooth bristol paper

tortillion

1 Find the Horizon Line

Start by first finding the horizon line. Divide the paper by drawing the horizon line. This is the anchor for the entire drawing and creates the balance of the composition. In this example, the sky is the focus, and the horizon line is down in the bottom third of the drawing. Give yourself a few lines to represent the trees, just to know where things will go.

2 Create the Sky

Create the sky with horizontal patterns of light and dark. Apply the dark tones below the horizon line. The horizontal streaks in the sky will represent sky and clouds.

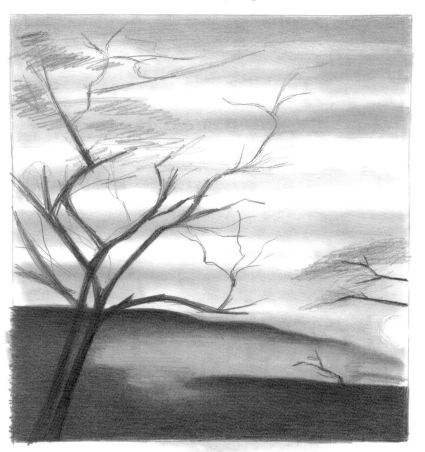

3 Create a Variety of Tones

Lightly blend out the horizontal strokes of the sky with a stump.

Make the top edge of the hill very dark, using firm pressure with your pencil. Work down and lighten your touch as you move toward the middle.

Fill in the bottom edge as dark as you can, and lighten your touch as you work up. Blend the entire area until it looks smooth. You may have to reapply your tones and repeat the process a number of times. Add the lines to represent the shapes of the trees.

You can see in the finished piece how dark it is toward the bottom, but lighter tones interrupt the darkness, giving it a foggy, hazy appearance in the middle. When drawing this area, do not fill in everything black. Allow this area to stay a bit lighter as you work.

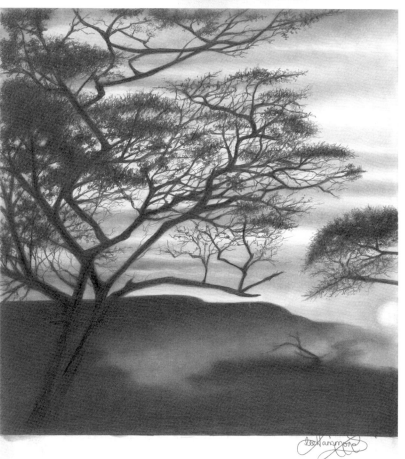

4 Finish the Trees

Finish the trees using firm dark strokes, filling the trunks and branches in completely. Create the look of leaves using tight circular strokes and dots. Make them as dark as you can.

Review your work and deepen any areas that appear too light. The contrast on this one makes it special.

Semi-Silhouette

This is an example of what I call a "semi-silhouette." Due to the high overhead lighting, only the tops of the trees are illuminated, with their bottom portions in deep shadow. The light was lifted out with a kneaded eraser.

Look at the shapes of the trees and see how the foliage seems to be formed into rounded clumps. Lifting the light off of the tops of these clumps makes them appear very full. The light has also been lifted off the grassy areas of the hills with a kneaded eraser.

Notice how the look of the terrain is created by the direction of the pencil lines and the erasing. In the midground, the horizontal strokes make the ground area appear flat. On the hills, the look of the incline is helped along by the pencil's and eraser's direction as well, since they were applied in the same upward direction.

The small deer in the foreground give you a great depiction of size and distance. Since they are so small, no detail shows. They remain silhouettes because they are in the shadows of the tree.

The pond offers up a mirror image of the shapes directly above. Water reflections will be covered later.

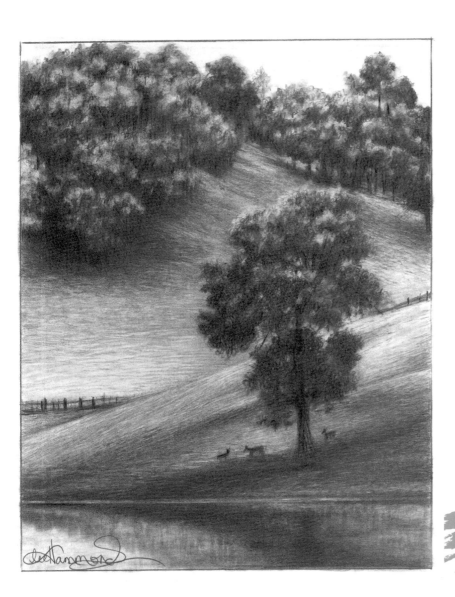

LEE'S LESSONS

Always keep a camera handy because you never know when you will see something that will lend itself to art.

AFTERNOON IN THE MEADOW
Graphite on smooth bristol
9" × 8" (23cm × 20cm)

DRAW TREE BARK

Now that we have drawn trees in silhouette form, it is time to move on to a tree in detail. A silhouette shows a tree's basic shape, but a close-up shows the detail and texture. This exercise will give you an idea of how to create lifelike texture in tree bark.

Materials

.5mm mechanical
 pencil with 2B lead

kneaded eraser

ruler

smooth bristol paper

tortillion

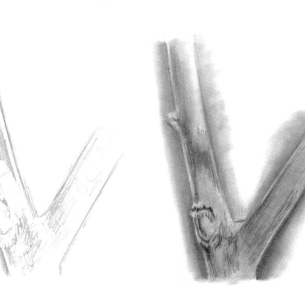

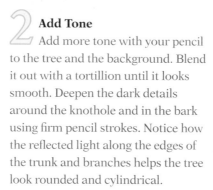

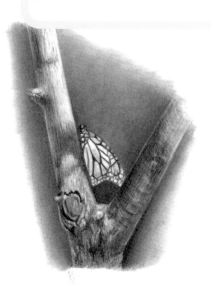

1 Create the Form
Draw the shapes of the tree lightly. The crook of the tree is a V-shape. With a small amount of shading, apply the tones to the left of the tree and on the tree using your pencil. The form being created resembles a cylinder. Keep the form of a cylinder in mind as you work.

2 Add Tone
Add more tone with your pencil to the tree and the background. Blend it out with a tortillion until it looks smooth. Deepen the dark details around the knothole and in the bark using firm pencil strokes. Notice how the reflected light along the edges of the trunk and branches helps the tree look rounded and cylindrical.

3 Deepen the Tones and Add Texture and Highlights
Deepen the tones in the background and blend again.

With firm pencil strokes, continue adding the look of texture to the tree bark. Add some curved strokes on the right limb to make its roundness more obvious. This gives it the illusion of being a birch tree.

Lift highlight areas out with a kneaded eraser. This makes the tree look more dimensional. The light area on the left limb gives the illusion of being lit by sunshine.

(Just for fun, I added the monarch butterfly. While it may look complicated, it is easy if you look at it as a puzzle of connecting shapes. Little things like this can make even a small drawing look impressive.)

LEE'S LESSONS

Look for photo references that have good lighting. Having strong contrasts of tone helps give the drawing more intensity.

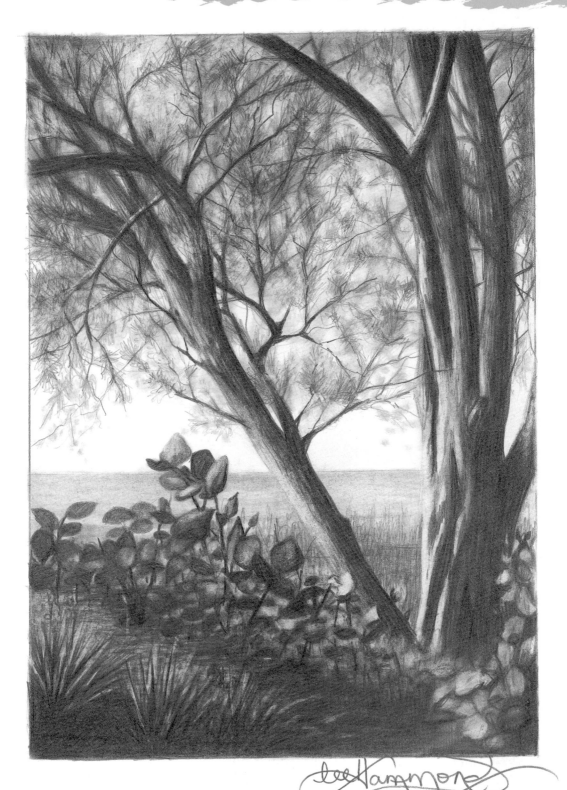

Tie It All Together

This drawing is an example of applying everything we have learned so far. The composition has a clear horizon line just below the center, creating the look of distance.

The drawing has a good sense of a light source coming from the back left. This illuminates the trees along the left side. The extreme contrasts of light and dark give the tree trunks and limbs an obvious cylindrical look.

The shading used in the foliage of the trees causes it to look somewhat out of focus and makes everything else look more distinct.

MY FAVORITE SPOT AT THE BEACH
Graphite on smooth bristol
8" × 6" (20cm × 15cm)

Receive free downloads when you sign up for our free newsletter at artistsnetwork.com/newsletters_thanks.

DRAW PINE TREES

Study the finished drawing for the elements of scenery we have covered in this chapter. This scene has a less dramatic light source, which gives it a foggy appearance. The lighter tones in the background place all of the attention on the pine trees in the foreground.

A kneaded eraser played a very important part in this piece. Not only the pine trees, but the clouds and the highlights on the hills and grass were all lifted out after these areas were blended.

This is a great time to use the viewfinder and create a segment drawing! Two or three pages of trees entered into your segment drawing notebook will increase your skills immensely.

Materials

.5mm mechanical
 pencil with 2B lead

kneaded eraser

ruler

smooth bristol paper

tortillion

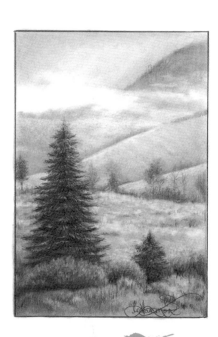

GOOD MORNING FROM BRYAN FLATS
Graphite on smooth bristol
8" × 6" (20cm × 15cm)

1 Create the Trunk and Branches

Draw a vertical line to represent the tree trunk, thicker at the base and smaller toward the top.

Starting at the top, draw outward from each side to create branches. Slowly increase the size of the branches as you work down to the base. Make sure that some of the branch lines cross over the trunk in front. Blend out the drawing with a tortillion to create a gray tone.

2 Add Tone

With firm pressure on your pencil, create dark limbs over the shading. Use random lines to create the look of pine needles. To keep it from looking too full, use a kneaded eraser to lift out light on the tops of some of the branches. This light in front breaks up the trunk, making it appear as if tree branches are coming out toward you. Due to the perspective, their length is lost. This is called *foreshortening*.

DRAW A COMPLEX SCENE

Now it is time for you to put your knowledge and skill to work and create a beautiful park scene. It has all of the elements of scenery we have covered so far. The extreme contrast of light and dark makes it very dramatic. A clear sense of sunlight and shadow can be created with your erasers and firm pressure on your pencil.

Materials

.5mm mechanical
 pencil with 2B lead

kneaded eraser

ruler

smooth bristol paper

tortillion

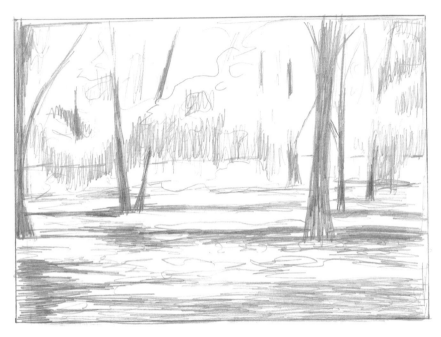

1 Place the Shapes

Draw the horizon line across the paper. In this case, it is a little bit above center.

Using my example as a guide, block the shapes in loosely with your pencil. At this stage we are creating the placement of the trees and the major shadow patterns.

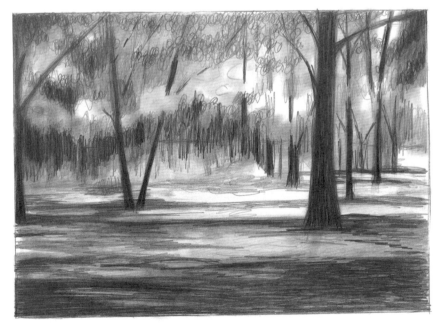

2 Focus on Pencil Strokes

Deepen the patterns with firm pressure on your pencil, and fill in the tree trunks until they are very dark.

Make the pencil lines in the background vertical to represent trees, and the ones in the foreground horizontal to represent the flat ground.

To start the look of foliage above, use small circular strokes. The direction of your pencil strokes is important since it creates the surface you are drawing. Blend the tones out with the tortillion to create a gray tone throughout.

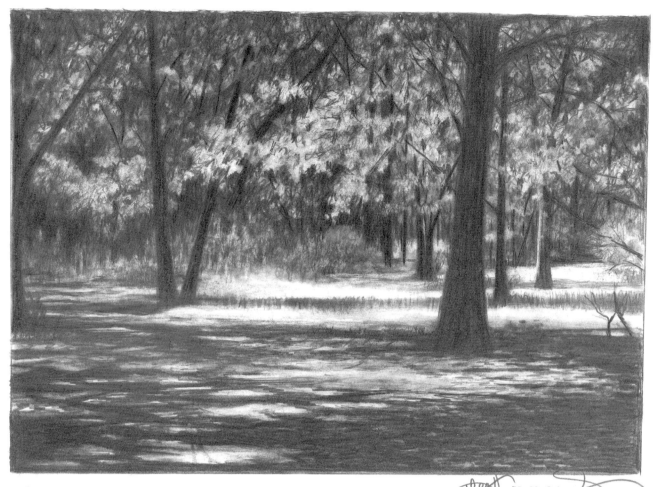

3 Detail the Foliage and Deepen the Contrasts

Start with the foliage of the trees. With firm pressure and small circular strokes with your pencil, deepen the tones to create the illusion of clumps. To create the look of the sunlit areas, draw the light out with a Tuff Stuff eraser. Use the same circular marks you did when using the pencil. You may need to use pressure on the eraser to get the graphite to come off. Go back and forth, adding dark and lifting light until it looks realistic.

Deepen the contrasts in the foreground. Use firm pressure on your pencil to create horizontal strokes. Use the Tuff Stuff eraser for the brightest highlights. Use a kneaded eraser for the smaller, more subtle highlights. Create the subtle look of bushes in the background with the kneaded eraser.

SUMMER PARK SCENE
Graphite on smooth bristol
6" × 9" (15cm × 23cm)

LEE'S LESSONS

When creating very dark tones, hold your pencil more perpendicular to the paper to prevent your lead from breaking.

Different erasers create different looks. The Tuff Stuff eraser will lift out large areas of white with more distinct shapes. The kneaded eraser will gently lift out subtle highlights that are not as distinct.

DRAW GRASS

You now have experience in drawing skies, backgrounds, silhouettes and trees. Now we will move in closer and start drawing the close-up details of both animals and nature. Let's start with grass.

Knowing how to draw realistic grass is essential for drawing animals. You've seen how to draw it from a distance, but these demonstrations will show you how to draw short grass and longer reeds up close.

Materials

.5mm mechanical
 pencil with 2B lead

kneaded eraser

ruler

smooth bristol paper

tortillion

SHORT GRASS

1 Start With Vertical Strokes
Start with two strips of short, vertical pencil strokes.

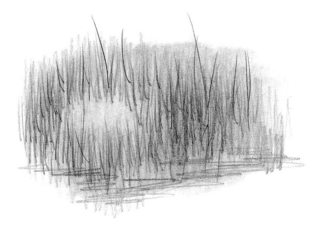

2 Blend the Lines
Blend the lines with a tortillion and then reapply more pencil strokes. Use a firm stroke for a dark line. Use quick strokes so the lines taper at the end. Be sure to make them random as well, without the same line of origin.

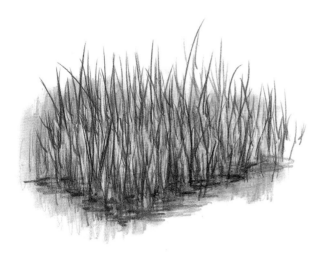

3 Lift Out the Light
Keep applying firm pencil lines, overlapping them as you go. Add some dark horizontal strokes underneath them to create the illusion of the ground. With a kneaded eraser and quick strokes, lift out the light grass blades.

LONG GRASS

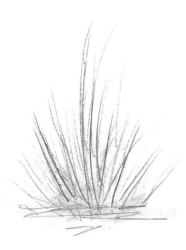 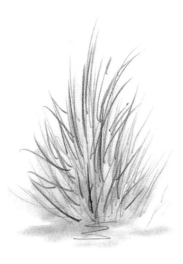 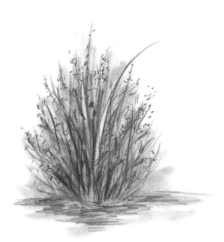

1 Start With Quick Strokes
Start with longer, quick pencil strokes. Notice how these come out of the same spot and radiate outward.

2 Blend the Lines
Blend out the pencil lines with the tortillion, and then reapply the lines with firm strokes.

3 Add Texture
Continue to apply dark, quick strokes with the pencil. Add small dots, or stippling, to the outside edges for the look of texture. This could be the illusion of small leaves or berries. Use the kneaded eraser to lift out the lighter reeds and grass.

GRASS CLOSE-UP

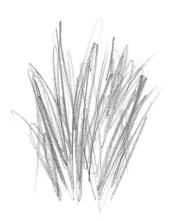 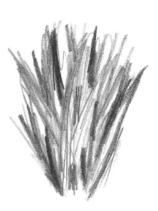 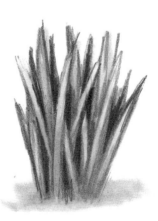

1 Draw a Clump
Create a clump of grass with loose, vertical pencil lines.

2 Add Darks
Add dark grass blades with your pencil.

3 Apply Lights and Darks
Define the blades with light and dark. Use the pencil for filling in the darker ones behind. Blend the lighter ones, and then lift the light tones out with the kneaded eraser.

Leaves Up Close

We have studied how leaves look in silhouette form, but to draw them close-up, you will need to add the details. Sometimes you will need to do both in one drawing. The leaves will appear different, depending on the light.

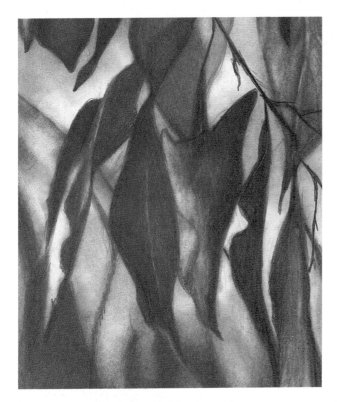

Silhouette

This close-up shows the shapes of the leaves in a partial silhouette. While most of the leaf is black, a small amount of light appears along the edges and the veins. It is subtle, but this type of light makes the realism.

Subtle Detail

This close-up reveals the details. The extra light shows the veins and the stems clearly. Look closely and study how the light shines along the edges.

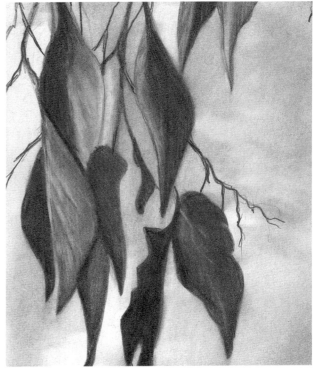

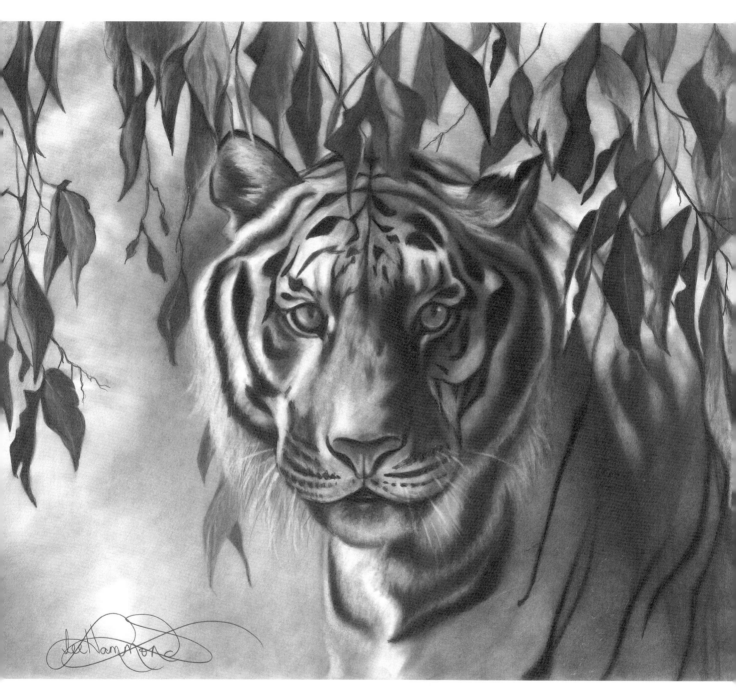

Use Leaves to Frame the Subject

This drawing is one of my personal favorites. The tiger is beautiful, but the addition of the leaves makes this scene a real eye-catcher. Instead of taking away from the tiger, the leaves act as a natural framework. The placement of them actually leads your eye to the center, straight into the eyes of the tiger.

EYES OF THE TIGER
Graphite on smooth bristol
11" × 14" (28cm × 36cm)

Leaves Enhance a Scene

Here are more examples of how leaves can enhance the drawing of an animal. The elements you include in a drawing help tell a story. Without those elements you have a portrait, not a scene.

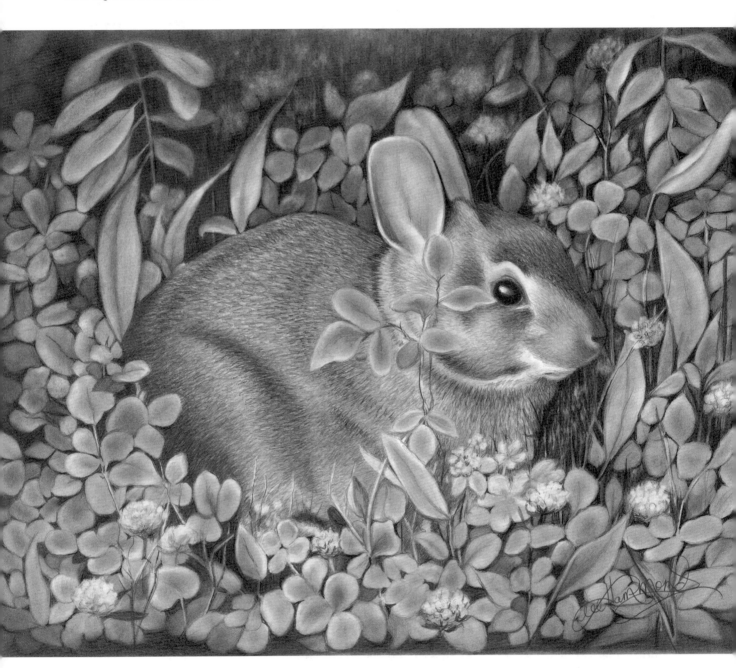

Leaves Gone Wild!

I started out with the bunny and a few of the clover leaves around it. But I was disappointed with it that way because it looked too much like a holiday greeting card. I wanted something more serious for my efforts. After adding clover to the entire page, I was happy with the results (even though I was worn out)!

SPRING BUNNY
Graphite on smooth bristol
11" × 14" (28cm × 36cm)

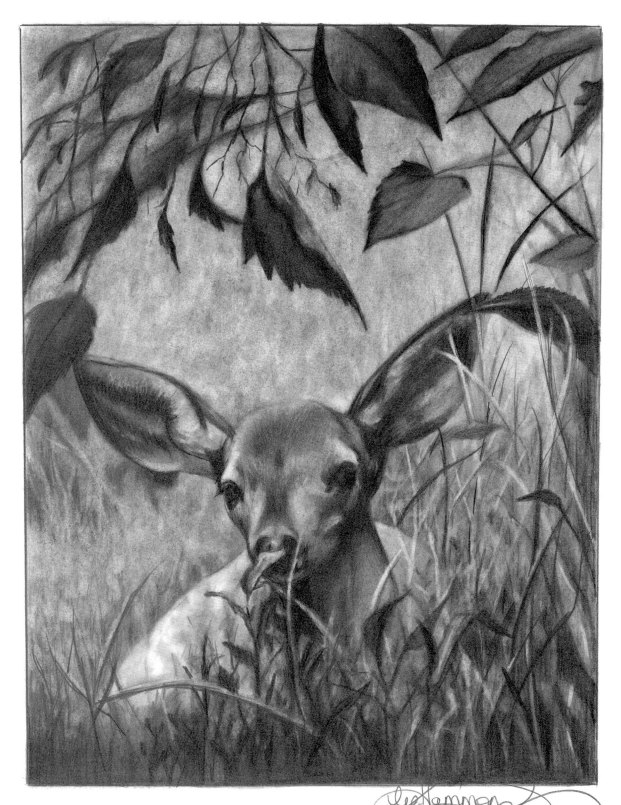

Silhouette and Detailed Leaves

This little fawn would be a cute drawing all by itself, but the addition of the grass and leaves makes it special. I used the blended effect in the background to give it an out-of-focus appearance. With the kneaded eraser, areas of light were lifted for the look of texture. The grass around the fawn was created with pencil lines and the Tuff Stuff eraser. The leaves are a combination of silhouette and subtle detail.

IN THE THICKET
Graphite on smooth bristol
10" × 8" (25cm × 20cm)

Get a bonus demonstration from *Amazing Crayon Drawing with Lee Hammond* at artistsnetwork.com/drawanimalsinnature.

57

DRAW LEAVES

Use this exercise to learn how to draw leaves. Even though it is a small piece, the creative use of the tones in the background makes it appear very realistic. The out-of-focus background makes the leaves look very crisp when you are done.

Materials

.5mm mechanical
 pencil with 2B lead

kneaded eraser

ruler

smooth bristol paper

tortillion

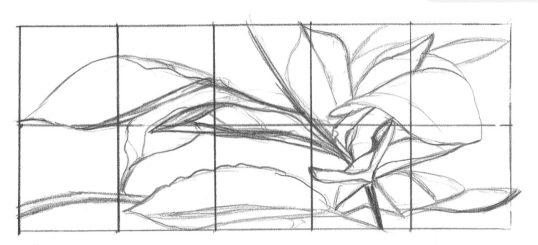

1 Draw the Grid
Lightly draw a ten-box grid in the middle of your drawing paper with two rows of five one-inch (25mm) squares. Carefully and lightly draw the shapes you see within each square until your line drawing looks like mine. When you are happy with your shapes, carefully remove the grid lines with your kneaded eraser.

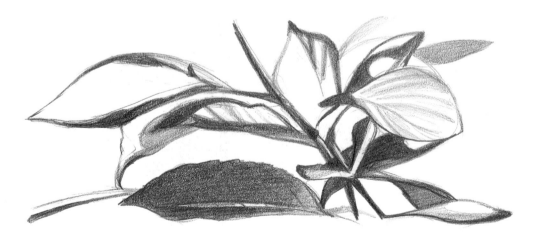

2 Add Tone
Always start with the darkest tones. Apply them with your pencil. Then add the medium tones. At this point it looks like a puzzle of geometric shapes.

3 Blend the Tones and Apply Shading

Use the tortillion to blend out the tones of the leaves. The gray tones give the drawing depth and give the illusion of more leaves being in the background. Look at all of the subtle patterns within each leaf, and create those shapes with the blending. Lifting the subtle highlights out along the edges and the veins makes the leaves look real. Use the tortillion to create the shading in the background. Create the illusion of more leaves with blurred shapes that resemble leaves.

4 Finish

I had you draw this exercise in the middle of your paper for a reason. If you want to, you can extend the drawing and make it look like this. Add more leaves below, and then draw the stem upward and add more leaves there. Study the patterns of light and dark, for each leaf is different. Create the blurred background by drawing in the shapes of leaves, and then blending them out into shades of gray with no detail.

Water

Many animals live in or around water. To draw water properly, you must change the way you think about it. Most people get stumped because they think of water too literally. They keep thinking of water as clear.

Although it is indeed transparent, water is highly reflective. Drawing water that looks realistic is actually about drawing the patterns of light and dark that are reflecting into the water, not the water itself.

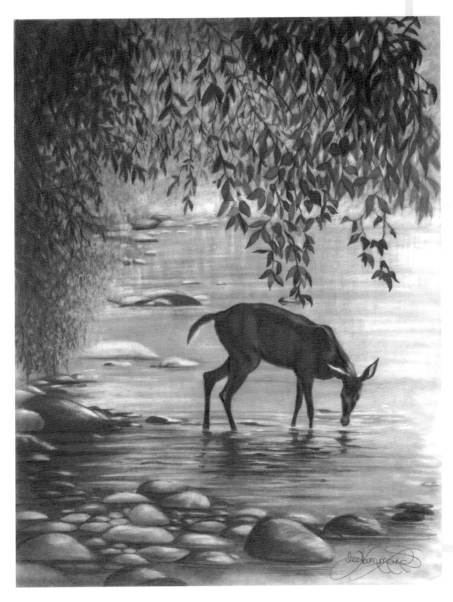

LEE'S LESSONS

Here are the most important things to remember when drawing water:

- *Since water is clear, you must draw the patterns of light and dark reflecting in the water.*

- *Water reflections are always directly below the object being reflected. Shadows can move or stretch out due to the light, but reflections are always seen directly below, regardless of the light.*

- *Water moves horizontally as you view it (unless it's a waterfall). The patterns of light and dark need to be drawn using horizontal pencil lines and shapes, much like drawing the sky.*

- *Rocks are like spheres with a reflection below.*

Water Reflects Light, Dark and Patterns

Look at the shape of the deer reflecting into the water below it. It is a mirror image. However, the image is broken and irregular due to the movement of the water. The image of the deer appears in the water as fragmented shapes.

When drawing ponds, you will always see rocks and stones. When drawing them, view them as spheres with their reflection below. A rock always has a dark underside with the light bouncing off the top or the side.

A PERFECT MOMENT IN NATURE
Graphite on smooth bristol
14" × 11" (36cm × 28cm)

Receive free downloads when you sign up for our free newsletter at artistsnetwork.com/newsletters_thanks.

DRAW ROCKS

Drawing rocks is actually quite fun. I like things with a lot of contrast, and rocks always deliver, especially when they are sitting in water. This exercise contains all of the same elements as the drawing of the deer and water. It will give you the practice you need for drawing realistic rocks.

Materials

.5mm mechanical pencil with 2B lead

kneaded eraser

ruler

smooth bristol paper

tortillion

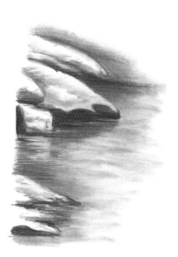

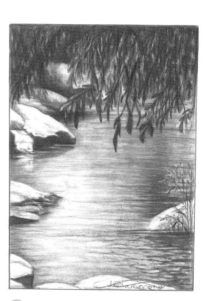

1 Draw the Rocks

To keep it simple, let's just draw a few of the rocks. Lightly draw in the shapes freehand. Since rocks come in all shapes and sizes, it isn't imperative that they match mine exactly.

Once the shapes have been drawn in, fill in the darkest areas found on the lower portions of each rock. Create the mirror image of the rocks in the water, directly beneath them. Use your pencil to draw in some horizontal lines in the water.

2 Create Tone

Lightly blend out the tones. Use a horizontal stroke with the tortillion when creating the water to help with the look of reflections. Reapply the pencil lines to make them appear again.

Deepen the dark tones of the rocks with your pencil to make them look as dark as possible. With the kneaded eraser, lift out the refections in the water, using quick horizontal strokes. Lift out the light mirror images of the light rocks on the left.

3 Finish

Practice drawing this pond scene using all of the info learned so far. If you need some help drawing it, you could place an acetate grid over it.

POND SCENE
Graphite on smooth bristol
8" × 6" (20cm × 16cm)

Reflections

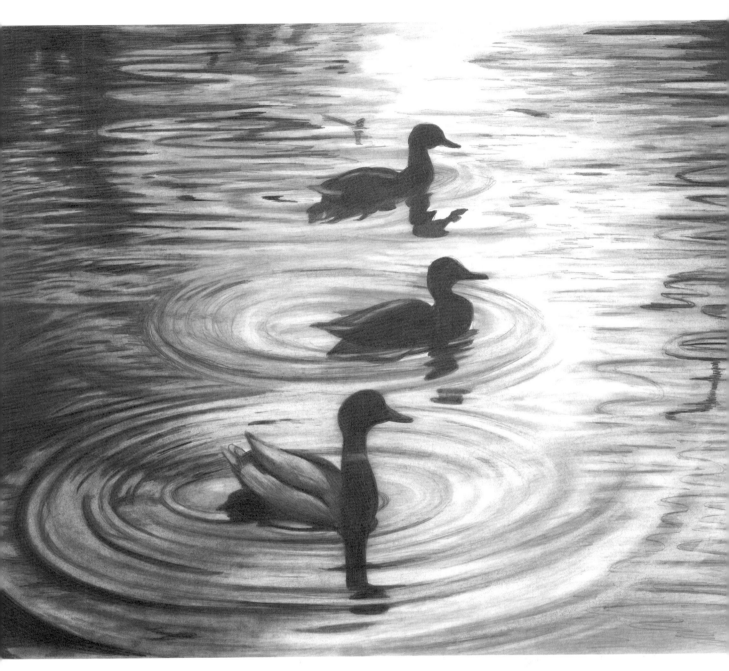

The Ripple Effect

You've heard of the ripple effect before, and this is a perfect example of it. The ducks are silhouetted against the light reflecting off the pond, but it is the water that really catches the eye. As the ducks move, the circular motion of the water creates fabulous patterns of light and dark. Look for this type of scene to draw. It can be a challenge, but it is worth it.

DUCKS AT SHAWNEE MISSION PARK
Graphite on smooth bristol
11" × 14" (28cm × 36cm)

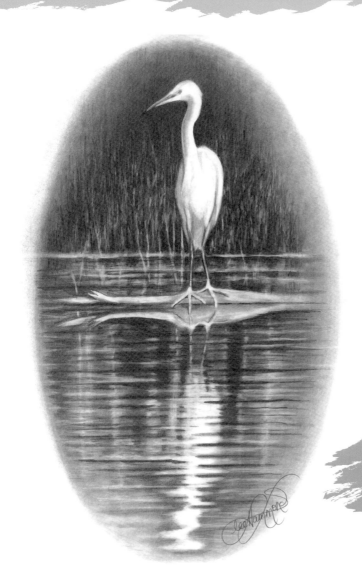

Create a Segment Drawing

This drawing is a great example of the reflections seen in nature. This white egret is beautiful, but as an artist, I am more drawn to its reflection below. Using the drawing as a reference, create a segment drawing of the reflection. Add this to your segment drawing notebook.

FISHING ON ROOKERY BAY
Graphite on smooth bristol
14" × 11" (36cm × 28cm)

Start With Patterns

Start the segment drawing with your two-inch (25mm) square. Apply the horizontal patterns with your pencil.

Blend and Lift

Blend the tones with a tortillion. Lift the white areas out with the kneaded eraser.

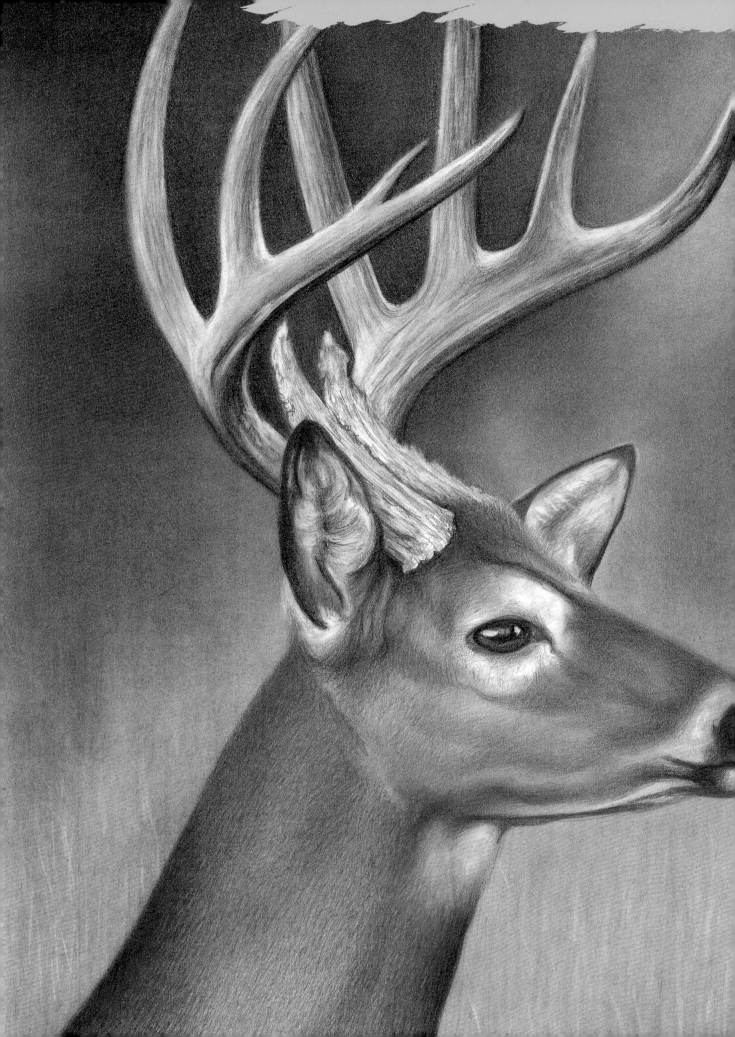

Animal Characteristics

Drawing animals is a fun and rewarding challenge for any artist. Animals are filled with unusual drawing elements, and each animal has a unique personality. Each species is special in its own way, and an entire career could be devoted to capturing their essence.

Now that you have the knowledge and experience of adding scenery to your animal drawings, you can become a true wildlife illustrator.

Let's begin with the basics. Like everything else, you must start slow and then gradually increase the difficulty.

CLOSE-UP OF A DEER
Graphite on smooth bristol
11" × 14" (28cm × 36cm)

Get a bonus demonstration from *Amazing Crayon Drawings* at artistsnetwork.com/drawanimalsinnature.

65

Basic Shapes in Animal Anatomy

The basic shapes are always present in the anatomy of an animal. You must study your subject carefully and identify these basic shapes before you begin to draw. This will make your drawing more accurate.

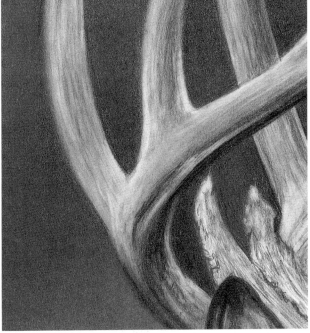

An Antler Is a Cylinder

The close-up study of an antler shows how the rendering can turn a basic cylinder into a believable object. The antler closely resembles the trunk of a tree. They are both made up of cylinders. The process for drawing them is identical. Draw this in your segment drawing notebook.

Anatomy and Shapes

This diagram shows how important the basic shapes are. You can clearly see the cylinder and the egg repeated in the anatomy of the deer. Understanding these shapes will make your drawing appear much more dimensional and realistic.

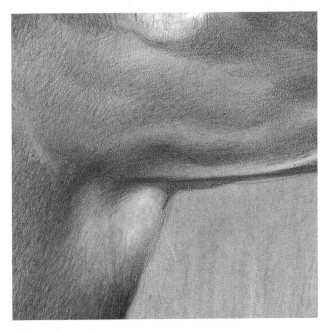

A Jaw Is an Egg

The egg shape is obvious in the jaw of the deer. The shadows and reflected light created with the five elements of shading make it look curved. The proper placement of the reflected light and shadows gives a subject dimension and realistic form.

Black & White

One of the most common mistakes beginning artists make is not developing tones properly. If an area appears black, especially if the animal has black fur, beginners have a tendency to just fill it in solidly. If an area appears white, they simply leave it empty, allowing the paper to stay pure white.

Both of these approaches are incorrect. Black and white are never pure. They are both affected by light and shadow and are actually various shades of gray.

Look for reference photos of things you think of as black or white. Try drawing them in your segment drawing notebook.

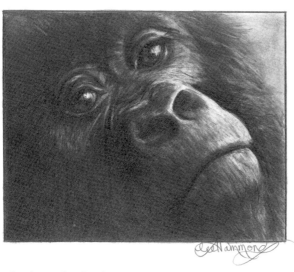

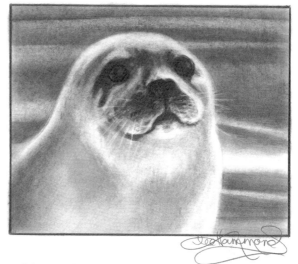

Black Isn't Black

This gorilla's fur is quite dark, but it isn't black. There is a hint of light reflecting off the fur. I lifted these light areas out with a kneaded eraser. On the darker left side, I filled in the area with pencil strokes going in the direction of the fur, so if the pencil lines show, they are consistent with the surface. Simply filling it in with randomly placed lines just to make it dark would make this area look flat.

White Isn't White

Very little of this seal has actually remained pure white. Gray tones make this seal look realistic. The horizontal placement of the shading in the background gives the illusion of distance.

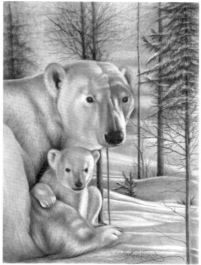

Combining Black and White

Very little of this drawing has been left pure white—only the highlight areas on the polar bears and the snow. The dark tree trunks appear almost black, but they have highlights from the light coming from the right side.

Get a bonus demonstration from *Amazing Crayon Drawing with Lee Hammond* at artistsnetwork.com/drawanimalsinnature. **67**

Eyes

When drawing animals, you must capture the essence of their personalities. You will see the souls of many of these animals through their eyes.

In drawing eyes, draw what you see and not what you remember. We are so used to seeing people's eyes that those characteristics get automatically placed into our drawing. Resist the urge to put in the white of the eyes (the sclera) because it rarely ever shows up in an animal.

Study these detail shots from some of the drawings in the book. You can see how different the eye of each species is. Every animal has characteristics that are unique to it alone. You as the artist have the obligation to really study what you are drawing and to find these characteristics.

This is where your segment drawing notebook will come in handy. By isolating just the eye of an animal, you will come to a better understanding of what it is you are actually drawing.

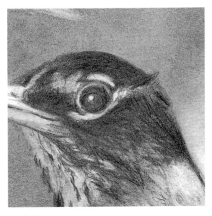

Robin Eye

The eye of a bird is very dark and shiny. Most of them will have a light edge around them as seen here.

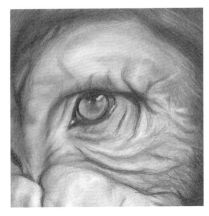

Chimpanzee Eye

Primates have eyes that closely resemble those of a human. The big difference is that the white of the eye does not show, making the eye appear much darker.

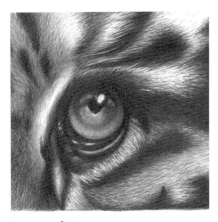

Leopard Eye

Eyes of cats have distinct pupils that enlarge or reduce according to the sunlight. You can see that the iris is lighter than the pupil. It has extreme values of light and dark surrounding the eye due to the patterns in the fur.

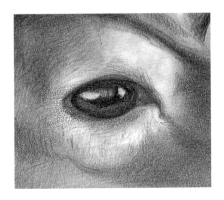

Deer Eye

Close observation shows that the pupil of a deer is elongated, not round. This is also seen in goats, horses and cows.

LEE'S LESSONS

Notice how all of the eyes have what is called a catch light. This is a small, bright reflection of the light source. To make the eye realistic, this reflection should be there. Sometimes it is large and takes over the eye, or there is more than one catch light showing. I always reduce the number of catch lights to one and make it half in the pupil (the black area) and half in the iris (the colored part). This makes the eye appear to be looking at you because you can see the pupil and the direction of the gaze.

DRAW A LEOPARD EYE

This segment drawing demonstration will give you some practice drawing eyes. Use the grid method to capture the beauty of a leopard's eye. The grid will help you draw the shapes and the patterns accurately.

Materials

.5mm mechanical
 pencil with 2B lead

kneaded eraser

ruler

smooth bristol paper

tortillion

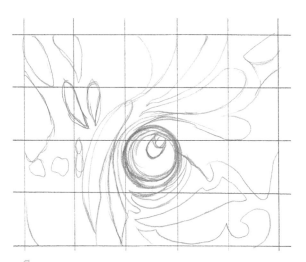

1 Grid the Eye
Use the grid to capture the shapes of the leopard's eye. Lightly draw the box on your drawing paper using one-inch (25mm) squares. Draw the shapes within each box as accurately as possible.

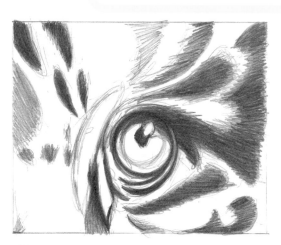

2 Draw the Dark Areas
Draw in the darkest areas first. Apply the pencil strokes with firm pressure, going in the direction of the fur. Do not make the pencil strokes solid or hard edged.

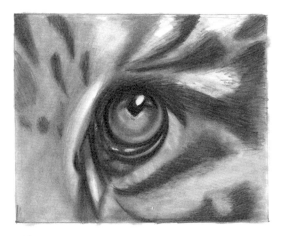

3 Blend Out to Add Tone
With a very dirty tortillion, blend out the lighter areas of the drawing to a shade of gray. Render the eyeball by adding tones around the pupil, then blend them out with the tortillion. Leave a white spot in the pupil for the reflection, and a subtle light edge around the pupil itself.

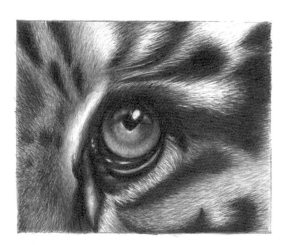

4 Detail the Fur
Add small dark hairs using short, quick pencil strokes. Create the lighter hairs the same way using a kneaded eraser molded into a razor's edge. The trick to this is not stopping too soon. Go back and forth continuing to add dark and light until you are satisfied.

DRAW SHORT FUR

Each animal has a different type of fur. There is a wide variety of colors, textures and markings in the animal world. No two are ever alike. I think that fur with distinct markings is actually the easiest to draw because the patterns help break it up into shapes.

The following demonstration will give you practice creating various types of short fur.

Materials

.5mm mechanical
 pencil with 2B lead

kneaded eraser

ruler

smooth bristol paper

tortillion

SHORT DARK FUR

1 Create a Swatch of Gray
Start with a series of vertical pencil lines, then blend them all out with the tortillion. This creates a swatch of smooth dark gray.

2 Add Short Pencil Strokes
Add short dark pencil strokes using firm pressure on your pencil. Remember to hold the pencil upright to prevent the lead from breaking.

3 Lift Out the Light Hairs
Lift out the light hairs with a kneaded eraser. Use the same short quick strokes as you did in the previous step.

SHORT LIGHT FUR

1 Create a Swatch of Light Gray
Apply the pencil first and then blend out with a tortillion to create a swatch of light gray.

2 Add Quick Pencil Strokes
Add quick pencil strokes with a light touch. Keep the lines short and delicate.

3 Deepen the Dark Area and Lift Out the Light Area
Add some more pencil strokes to deepen the dark lower area. Lift out the top light area with a kneaded eraser.

SHORT PATTERNED FUR

1 Create the Patterns
Lightly draw in the patterns of the fur's markings. Carefully fill them in with pencil lines that follow the direction of the fur.

2 Blend the Tones
Blend out the tones to a light gray using the tortillion. Reapply the dark pencil strokes to the areas with the dark markings.

3 Deepen the Patterns and Add Texture
Continue to deepen the markings with firm pencil strokes. Be sure that the dark patterns do not look outlined or too hard edged. They should bleed out into the light areas.

Using delicate strokes and a light touch, add some small hairs to the lighter areas for texture. Use the kneaded eraser to lift out some light hairs.

DRAW RACCOONS

Now put your short-fur knowledge to work in this demonstration. Because of the obvious texture of the short fur and the extreme texture of the tree bark, your pencil lines will be extremely important in this drawing. Follow the steps to create raccoons.

Materials

.5mm mechanical
 pencil with 2B lead

kneaded eraser

ruler

smooth bristol paper

tortillion

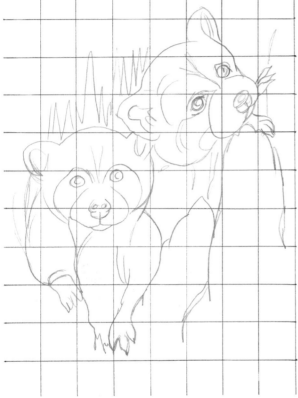

1 Grid the Raccoons
Use the grid method to capture the shapes of the raccoons on your drawing paper. Draw what you see in each box as accurately as possible.

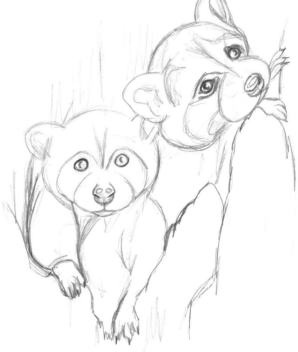

2 Remove the Grid Lines
Carefully remove the grid lines from your drawing paper with the kneaded eraser to reveal your accurate line drawing.

LEE'S LESSONS

A drawing like this takes time. Do not quit too soon. It is important to invest the amount of time required to create a drawing like this. It is the difference between a work of art and a quick sketch.

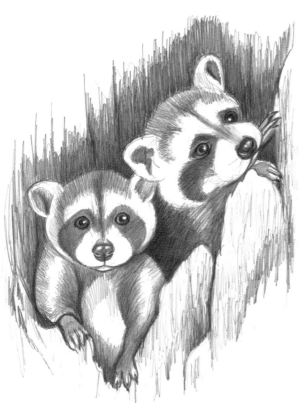

3 Create Texture

Using this example as a guide, apply firm pressure to your pencil to make firm strokes in the dark areas. Use vertical strokes for the tree bark and curved strokes for the raccoons' fur. The curved lines in the fur will help to create the roundness of the raccoons' bodies and heads.

4 Blend and Lift to Finish

With a tortillion, blend out everything to a gray tone. Reapply the dark areas once more, making them as dark as you possibly can. Build up the strokes in the raccoons' fur, going in the direction of the fur's growth. Use quick strokes that represent the hair length.

Study the patterns in the tree bark and apply these dark areas. Use vertical strokes to build up the look of the bark. Lift out the light areas of the tree bark with a kneaded eraser. Alternate back and forth between the pencil and the eraser until it looks dimensional.

Finish the drawing by lifting out the highlight areas on the raccoons with a kneaded eraser. Add small details like the whiskers and claws.

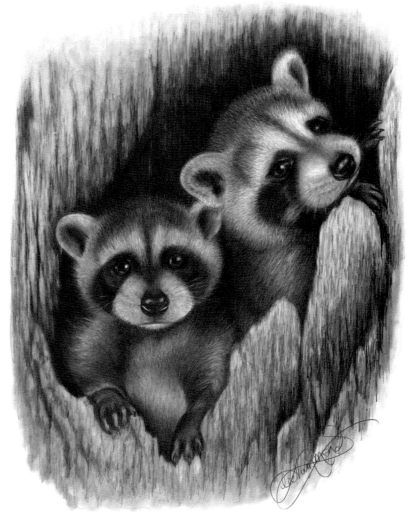

DRAW LONG FUR

Drawing long fur is similar to drawing short fur except the pencil lines are much longer. I sometimes find the long-haired animal easier to draw because long hair has more depth and, therefore, more separate areas to deal with. Because the pencil lines are longer, the area is filled much faster.

Materials

.5mm mechanical
 pencil with 2B lead

kneaded eraser

ruler

smooth bristol paper

tortillion

LONG, DARK STRAIGHT FUR

1 Create Long Strokes
Apply the pencil with long, quick strokes.

2 Blend Until Smooth
Blend the pencil strokes with a tortillion until smooth.

3 Lift Out Light Hairs
Reapply the pencil strokes for more depth of tone. Lift some lighter hairs out with the kneaded eraser to make it look thicker.

LONG, LIGHT WAVY FUR

1 **Apply Quick Strokes**
Apply the pencil with long, quick curving strokes.

2 **Blend Until Smooth**
Blend the pencil strokes with a tortillion until smooth.

3 **Add Texture**
Reapply the pencil strokes to add texture. Lift some lighter hairs out with a kneaded eraser. Use the same curved strokes.

CURLY LAYERED FUR

1 **Apply Curved Strokes**
Apply pencil strokes following the curves in the fur.

2 **Blend Until Smooth**
Blend the area with a tortillion until smooth.

3 **Deepen the Tones and Lift Out the Highlights**
Deepen the tones by adding more pencil lines. Make it darker in the recessed areas of the curls. Lift out highlights with a kneaded eraser. These should be placed in areas that protrude.

DRAW A LION

I created this drawing from a photo I took at the zoo. The lion has a combination of long and short fur. Because the fur is so extremely short on the face, you do not see much texture. His face is done more with shading and blending than with pencil strokes.

Follow the steps to draw your own lion.

Materials

.5mm mechanical
 pencil with 2B lead

kneaded eraser

ruler

smooth bristol paper

tortillion

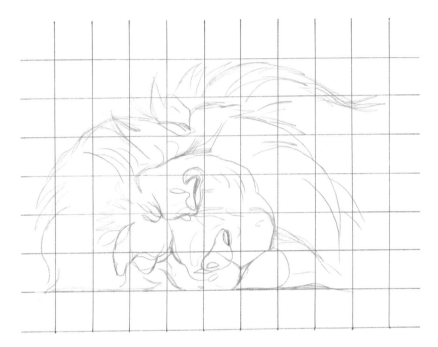

1 Grid the Lion
Use the grid method to draw the shape of the lion. Lightly draw the grid lines on your drawing paper. Draw what you see, one box at a time.

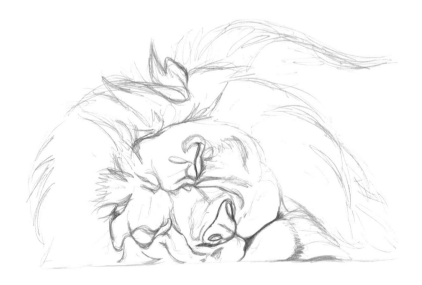

2 Remove the Grid
Use a kneaded eraser to carefully remove the grid lines and reveal your accurate line drawing.

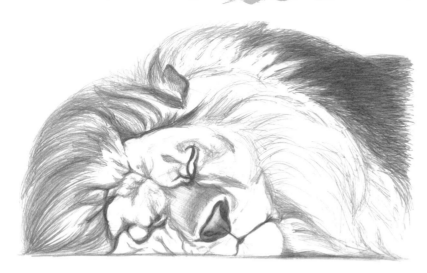

3 Apply Tones and Build Up the Mane

Create the darkest tones first. This lion has a very dark mane, so build it up using long pencil lines. Be sure your pencil lines go in the direction the hair is going.

Move down and apply the dark tones into the face. Start with the nose and then work out to the folds and creases of the face. Even at this point, the drawing is taking on a realistic appearance.

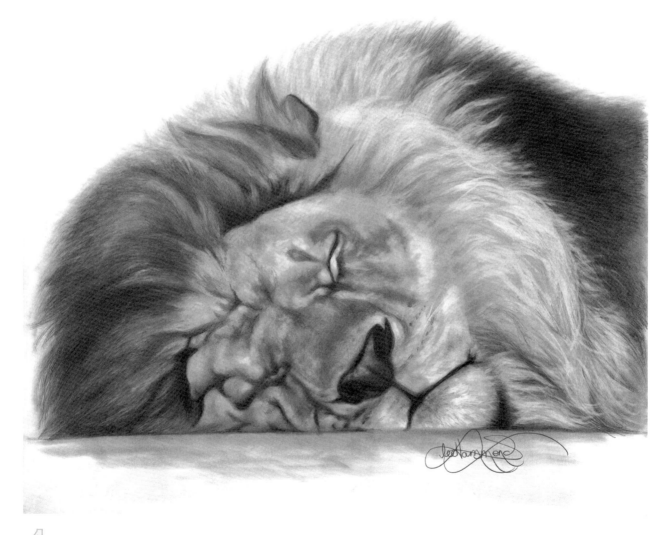

4 Smooth Tones and Add Highlights

Add some smoothness to the tones by blending with a tortillion. This softens the tones and makes things look less severe, especially in the face.

With the kneaded eraser, carefully lift some highlights out of the face. This helps it look softer and more dimensional. Move out to the mane and add the lighter fur on the right side. Use the same long strokes you used when applying the pencil lines. Lift some light out of the dark areas for a fluffier look.

Place some shading beneath the lion to suggest the ground.

DRAW A TIGER

Once you have drawn this tiger in portrait form, you can draw one in its natural setting or add a background of your choice. Use the grid method to draw this beautiful tiger face.

Materials

.5mm mechanical
 pencil with 2B lead

kneaded eraser

ruler

smooth bristol paper

tortillion

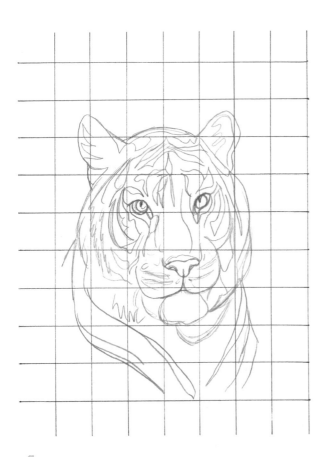

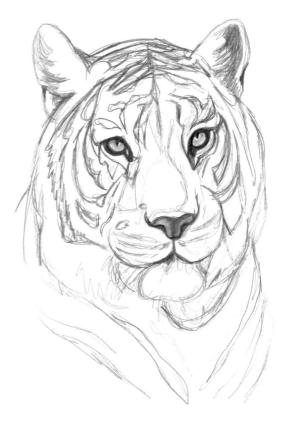

1 Grid the Tiger
Draw a light grid on your drawing paper. Draw the shapes you see in each box, one box at a time. This will help you get the shapes and markings of the tiger accurate. When you are sure of your shapes, carefully remove the grid lines from your paper with a kneaded eraser.

2 Render the Eyes and Nose
Add the tones to the eyes first, then blend with a tortillion to make them look smooth and shiny. Use a kneaded eraser to lift a hint of light around the pupils.

Create the nose the same way. Add the tones with the pencil first, then blend out with the tortillion.

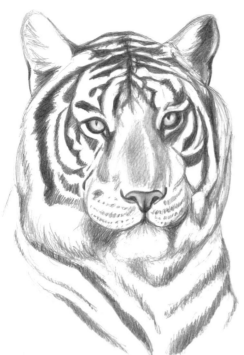

3 Add the Dark Patterns

With your pencil, fill in the dark stripes of the tiger. Be sure to fill them in using lines that replicate the direction of the fur. Without doing this, the stripes will look too solid, like objects sitting on top of the tiger instead of being part of the tiger.

Move to the areas that aren't quite as dark: the ears, the bridge of the nose and the areas below the chin. Apply a medium gray tone to these areas using short strokes.

4 Blend and Build Texture

Finish the portrait using the Hammond Blended Pencil Technique. Blending all of the tones out gives the drawing a softness that makes it look realistic. Once everything has been blended, reapply the small pencil marks to build up texture. This is a time-consuming process, but it is the frosting on the cake.

Lift out the tiny white hairs of the ears, chin and whiskers with a kneaded eraser pinched into a chisel edge, and lift out with quick strokes. If they appear too wide, simply take the pencil on either side and carefully narrow them down.

Take note of the whiskers on the right side. They appear light against the darker fur, but they change and appear dark when they go against the white background. These little details are so important.

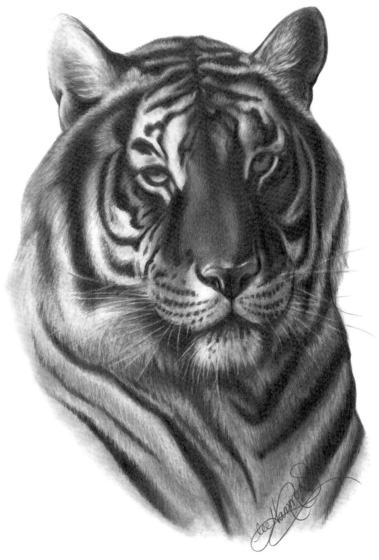

DRAW A CHEETAH

This demonstration will give you a wonderful opportunity to practice drawing realistically. Follow the steps to create a cheetah.

Materials

.5mm mechanical
 pencil with 2B lead

kneaded eraser

ruler

smooth bristol paper

tortillion

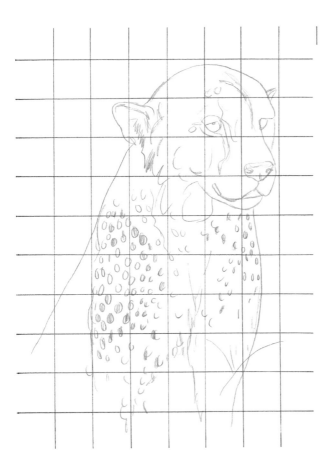

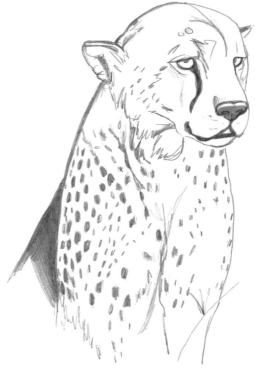

1 Grid the Cheetah
Use the grid method to capture the shape of the cheetah. Lightly draw the grid on your drawing paper and draw what you see in each box. When you are sure of your accuracy, carefully remove the grid lines with a kneaded eraser to reveal the accurate line drawing.

2 Add Darkness
Add darkness to the dots with your pencil. Study the face and the darkness of the eyes, nose and mouth.

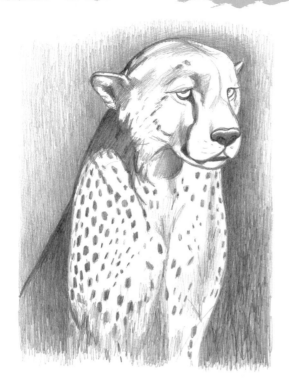

3 Create the Shadows and Lay In the Background

Create the look of shadows on the cheetah with your pencil. Remember the five elements of shading because these shadows help create the form of the anatomy.

With vertical pencil lines, fill in the background around the cheetah. It is darker on the right. This will help the big cat stand out.

4 Blend Tones

Using the blending technique, blend out all of the tones in the drawing. Start with the cheetah. Use the tortillion to soften the edges of the spots and to create the contours of the head and body. Once you have blended, you will have to reapply some of the spots and add more, especially to the head.

Move to the background and build up the tones with your pencil. Use vertical lines to replicate the shape and direction of the grass. Blend everything out with a tortillion to make it less distinct. In the front, use the pencil and kneaded eraser to create large blades crossing over the cheetah. Use delicate pencil lines to create the look of small plants.

This is not a quick or easy process. It will be necessary to go back and forth adding dark tones, blending, lifting light and adding small details. There is no set amount of reworking. Just keep going until you achieve the effect you want.

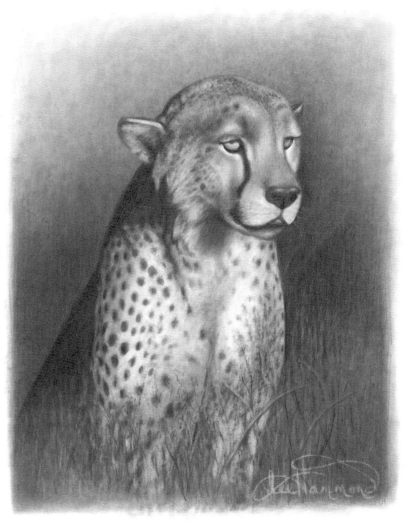

Segment Drawing

There are many details to consider when drawing wildlife and nature. The closer you get to your subject matter, the more difficult the details become. Let's break down some animal drawings into small areas and study the details. I recommend practicing these small segments in your segment drawing notebook.

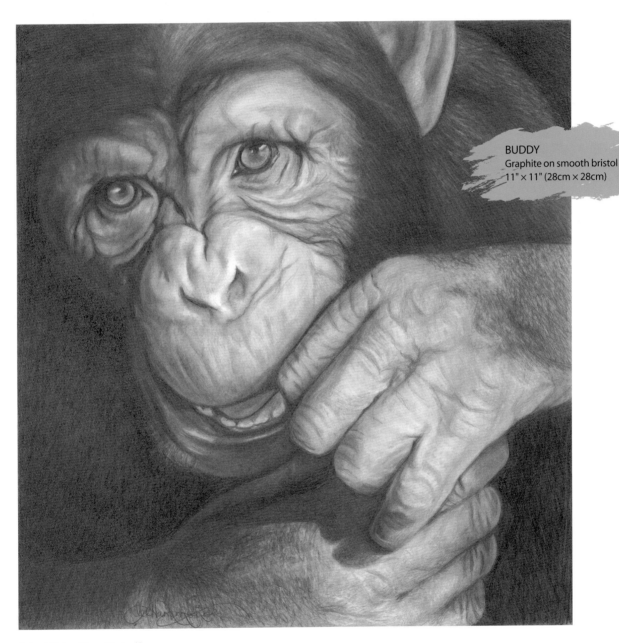

BUDDY
Graphite on smooth bristol
11" × 11" (28cm × 28cm)

It's All in the Details
Many small details were required to make this chimp look realistic. The combination of fur and skin was fun and challenging.

Receive free downloads when you sign up for our free newsletter at artistsnetwork.com/newsletters_thanks.

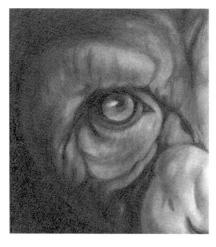

Wet and Shiny Eye

The tones were smoothed out with a tortillion. A kneaded eraser was used to lift out the catch light and highlights in the iris. The skin areas were blended to create a smooth look.

The crisper lines around the eye and the creases of the face were done in pencil. A kneaded eraser was used to lift highlights along all of the edges of the creases. Remember, anything with an edge gathers light.

Wet Mouth and Teeth

When drawing the mouth and teeth, it is all about the shapes. Drawing the teeth as puzzle piece shapes will help with accuracy. Since the mouth was wet, there were shiny areas. The highlights in the lower lip were lifted out with a kneaded eraser after the area was blended with a tortillion. Since this skin was smooth, you do not see creases and wrinkles.

Soft Dark Fur

This dark fur was built up using long, dark pencil strokes. It was then blended with the tortillion to make it appear soft. Light strands were lifted with the kneaded eraser.

Wrinkly Skin

The main thing about drawing an area like this is to not overdraw. Making these crease lines too harsh and too dark spoils the effect. Shading and blending the tones with a tortillion helped give the skin a more subtle look. Highlights were lifted out along the creases to give depth.

Rough Skin and Tiny Hairs

This is what I call a combination area. It is smooth first and textured second. The skin tones were applied with a pencil and then blended out with a tortillion to make it smooth. The pencil was then used on top of the blending to create subtle texture. This created the look of rough skin and tiny hairs. A very light touch with the pencil is required for this. If the pencil lines are too dark or too harsh, the effect is ruined.

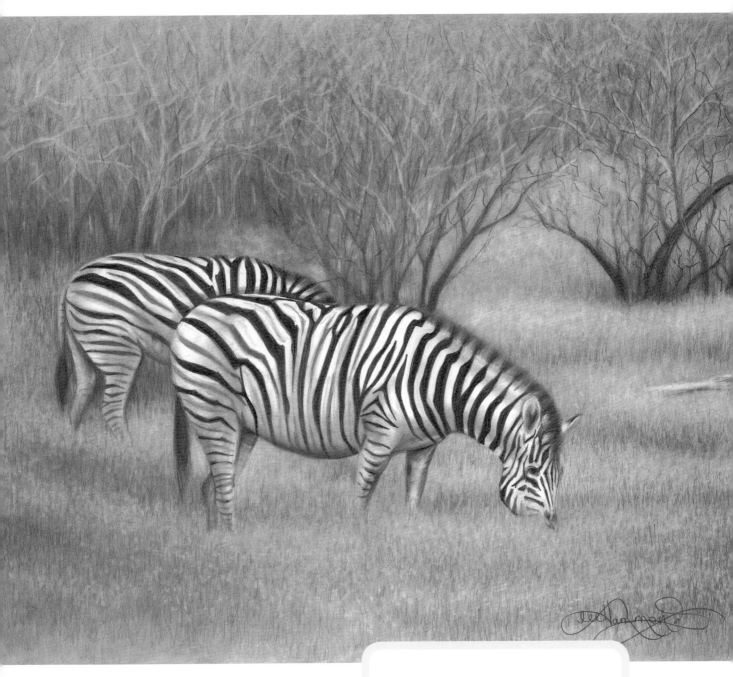

Contrast Enhances the Composition

The contrast between the soft tones of the grass and trees and the intense patterns of the zebras makes this composition really interesting.

ZEBRAS
Graphite on smooth bristol
11" × 14" (28cm × 36cm)

LEE'S LESSONS

Drawing in graphite always follows the same repetitive procedure:
1. Draw the shapes.
2. Fill in the dark tones.
3. Blend the tones.
4. Lift the light areas and details.

Stripes

Even though this is a study of black and white, remember the theory of black isn't black, and white isn't white. Through the patterns you can see the effects of light and shadow within this area. Look closely and see the cylindrical shape due to the five elements of shading. To create the zebras, I shaded the form first and then applied the stripes.

Trees

The trees in this study are quite subtle. The lighting is low key, so there aren't the extreme contrasts usually seen in an outdoor setting.

The tortillion and the kneaded eraser were the key players in creating these trees. After they were drawn in, everything was then blended out. This created the look of a dense thicket. Once the trunks and branches were lightly drawn back in, the kneaded eraser finished them off by lifting the light from the limbs on top.

Grass

The grass was drawn using the same procedure as the trees. First the vertical strokes were drawn in to create the look of grass. Then everything was blended out with a tortillion. The light grass was lifted with a kneaded eraser as the final step.

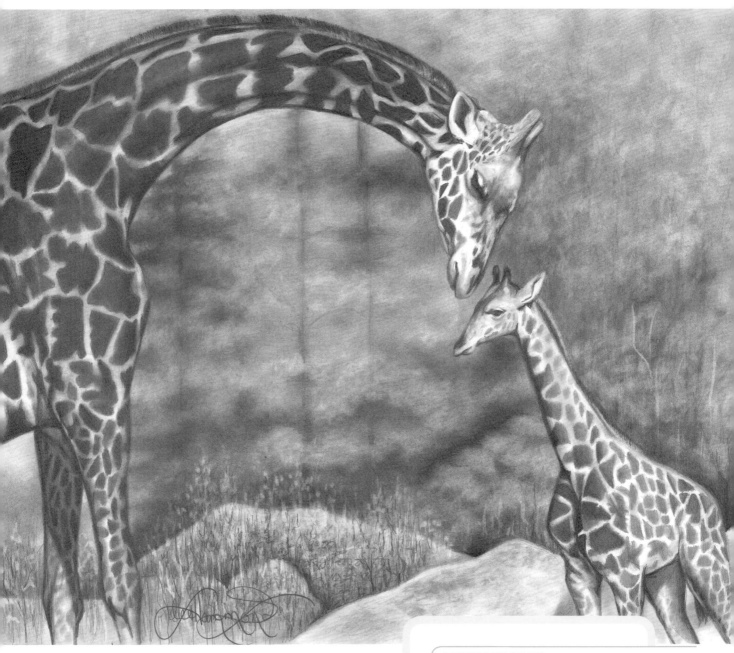

Balance in Composition Can Be Challenging

Much to my surprise, I had a difficult time capturing what I wanted compositionally with this drawing. The huge difference in size between mommy and baby made getting them on the drawing paper in a way that they both could be seen quite a challenge. Because of the empty space between the two giraffes, no matter how I placed them, the baby was overwhelmed and looked like it was being pushed off the page. To compensate for this, I had to sacrifice some of the larger giraffe.

THE LONG AND SHORT OF LOVE
Graphite on smooth bristol
11" × 14" (28cm × 36cm)

LEE'S LESSONS

Sometimes a photo will not be everything you need for a drawing. This is where artistic license comes in. Composition is hugely important, so make sure you work out the balance of it all before you just jump in. Change it if necessary.

Patterns

Patterns on an animal are always second to the form. The patterns on this giraffe would look unrealistic if the form of its anatomy was not visible beneath. The shading placed beneath the patterns gave the neck the look of muscles and a cylindrical shape.

Grass and Boulders

Reflected light was laid in along the edge of the boulders after their shapes had been blended smooth. The vertical strokes of the pencil created the look of grass. A kneaded eraser was used to lift out the light stems and details.

Trees

These trees appear to be in the distance due to the blended approach. The subtle shapes of light and dark give the illusion of trees. Keeping them out of focus keeps them from competing with the giraffes, making the giraffes seem crisp and in focus.

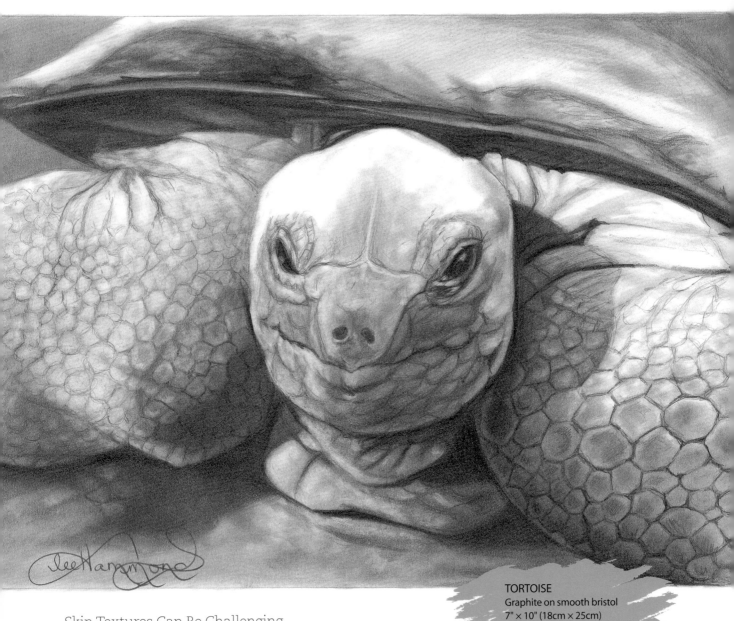

Skin Textures Can Be Challenging

Not all animals have fur, but this does not necessarily mean they are easier to draw. Skin textures can be complicated. The segment drawing method can help you work out the problems and gain a better understanding of what you are actually looking at. Although this is not a small segment drawing like the ones I put in my notebook, as a close-up it provides the same benefit. It allows you to see all the details and surfaces of the subject matter.

TORTOISE
Graphite on smooth bristol
7" × 10" (18cm × 25cm)

Smooth Texture

This area is very smooth. Due to the overlapping surfaces and the shell extending over the skin below, there are deep shadows. The darkness under the shell makes it look elevated. There is reflected light along the edge of the shell. (Remember the rule about edges.) The shell itself was blended with a tortillion to make it look smooth.

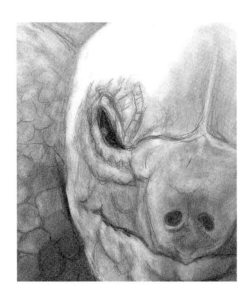

Semi-Rough Texture

This area of the face is a combination of textures. The skin is a little bumpy around the eye and mouth, but not deeply creased. The top of the head is quite smooth. Creating bumpy skin like this requires remembering the sphere. The gently raised areas have the same elements. The light areas were lifted with a kneaded eraser.

Rough Texture

The texture of the tortoise's leg is like a honeycomb. Drawing the shapes in was very much like putting a puzzle together. When shading it, I found that the center of each honeycomb segment was a bit darker, and there was reflected light around each one of them. This made the creases between them look recessed. The reflected light was lifted with a kneaded eraser.

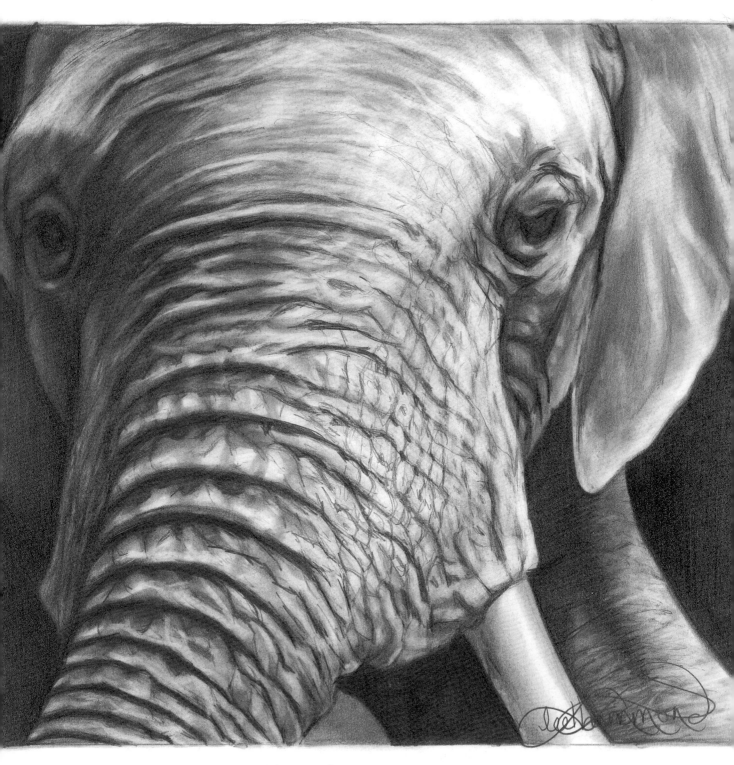

Wrinkles and Folds Contrast With Smooth Areas

This is another example of an animal with texture, not fur. The intense wrinkles and folds make this a complicated study. By closing in on the elephant's face, all of the details show.

Notice the smooth areas of the ear and tusk. Practicing all of these types of surfaces will make you a better artist.

HERE'S LOOKIN' AT CHA!
Graphite on smooth bristol
8" × 8" (20cm × 20cm)

Wavy Surface

This ear area almost resembles a piece of fabric. Because it is a flat surface, there is a huge amount of reflected light all around it. The surface itself has a wavy appearance. It was created by drawing patterns of light and dark and then blending them out. All of the light was lifted with a kneaded eraser.

Rounded Surface

This area with its smooth rounded surface is a total cylinder. The smooth blending made this tusk look perfectly rounded.

Textured Surface

This area is highly textured. If you compare its look to fabric, this would be an interlocking fold, with one raised surface overlapping another. Each raised surface creates a ridge. That means there is reflected light along each one. Because it is raised, there is also a cast shadow below it. Look for these details before you begin to draw.

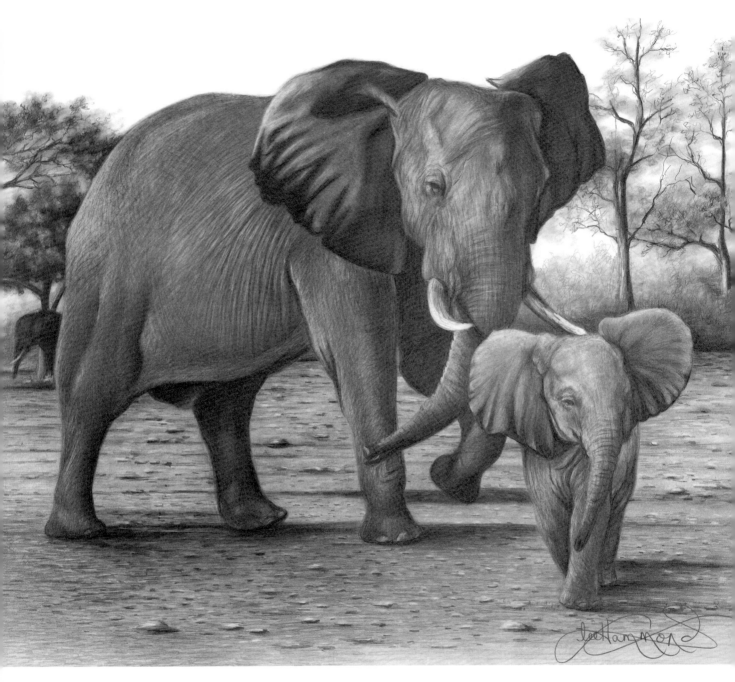

Panoramic View

While the textures here are not as evident as in the close-up elephant image, even from this view, the texture of the skin is an important feature. If these elephants had been drawn perfectly as far as the shapes go, but the skin looked too smooth, they would not look realistic. All aspects of an animal must be included in your drawing for it to be an accurate depiction.

AFRICAN ELEPHANTS
Graphite on smooth bristol
11" × 14" (28cm × 36cm)

Receive free downloads when you sign up for our free newsletter at artistsnetwork.com/newsletters_thanks.

Elephant

This segment is similar to the previous elephant segments. While the ridges are not as distinct, you can still see them. They were created with smaller, lighter pencil lines. The patterns on the ear are almost identical.

Trees

The blending in the foliage makes the trees look a bit out of focus, while the extreme light and dark on the trunks indicates the light source coming from the left.

Ground and Rocks

The ground was created with a horizontal application, which helps with the illusion of distance. The rocks are light on the top and dark on the bottom, resembling the sphere exercise.

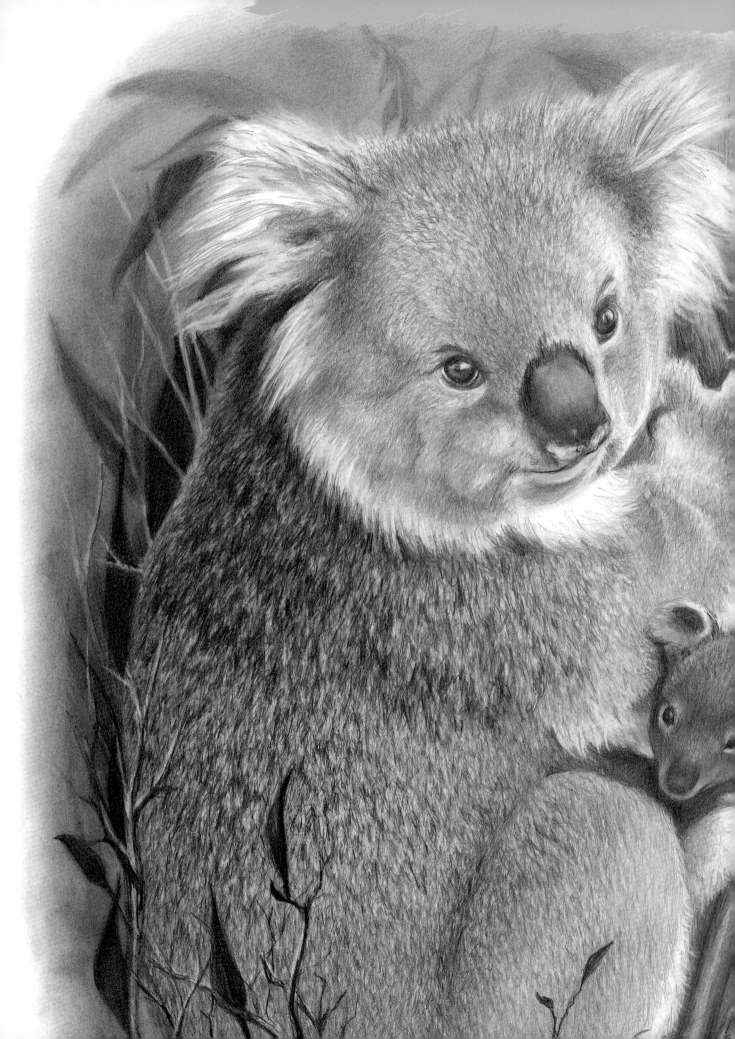

Land Animals

Woodland creatures make wonderful illustrations.
This is where the surroundings play an important part
in the drawing. Without the addition of the natural
surroundings, all you have is an animal portrait.

MOMMY AND ME
Graphite on smooth bristol
14" × 11" (36cm × 28cm)

Get a bonus demonstration from *Amazing Crayon Drawings* at artistsnetwork.com/drawanimalsinnature.

95

Segment Drawing

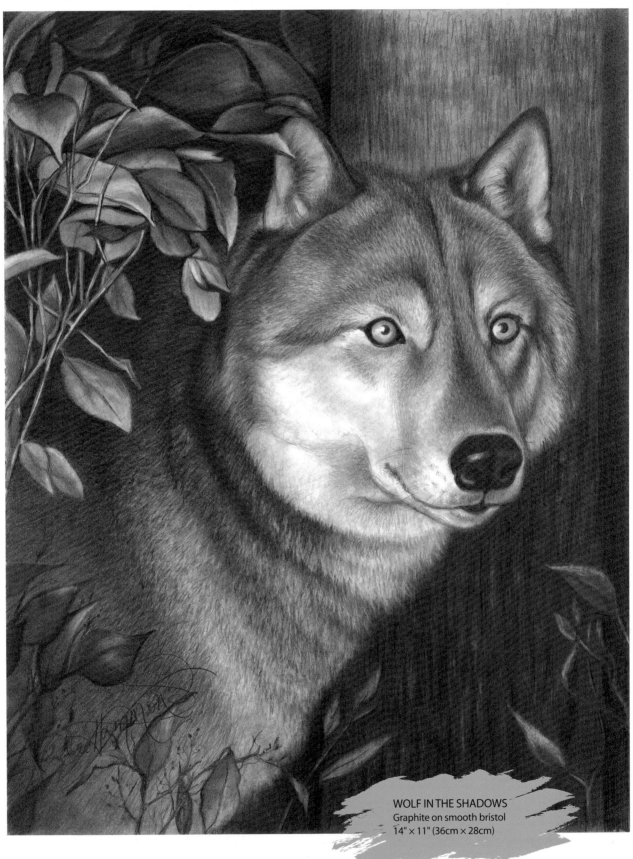

WOLF IN THE SHADOWS
Graphite on smooth bristol
14" × 11" (36cm × 28cm)

Receive free downloads when you sign up for our free newsletter at artistsnetwork.com/newsletters_thanks.

Nose

When drawing this wolf, I realized the nose was shaped the same as many other dogs I had drawn in the past. Recognizing this, I was able to render it more accurately. Knowledge of your subject is so important.

One of the most important things to remember in this drawing is the reflected light. Due to the wet surface, the light reflects off the curves and edges. You can see it reflecting off the edges of the nostrils and along the upper lip.

Leaves

When viewed as a segment, these leaves look a bit abstract. Carefully draw the shapes first and then fill in the dark areas like a puzzle. Render the leaves within the square using blending and lifting techniques.

Fur

This section is nothing but texture. There are no distinct shapes to capture. It will give you practice with the pencil and eraser using quick strokes and building up.

Ear

When viewed like this, the ear looks like an inanimate shape. The key is to forget what you are drawing, and study the shape, tones and textures.

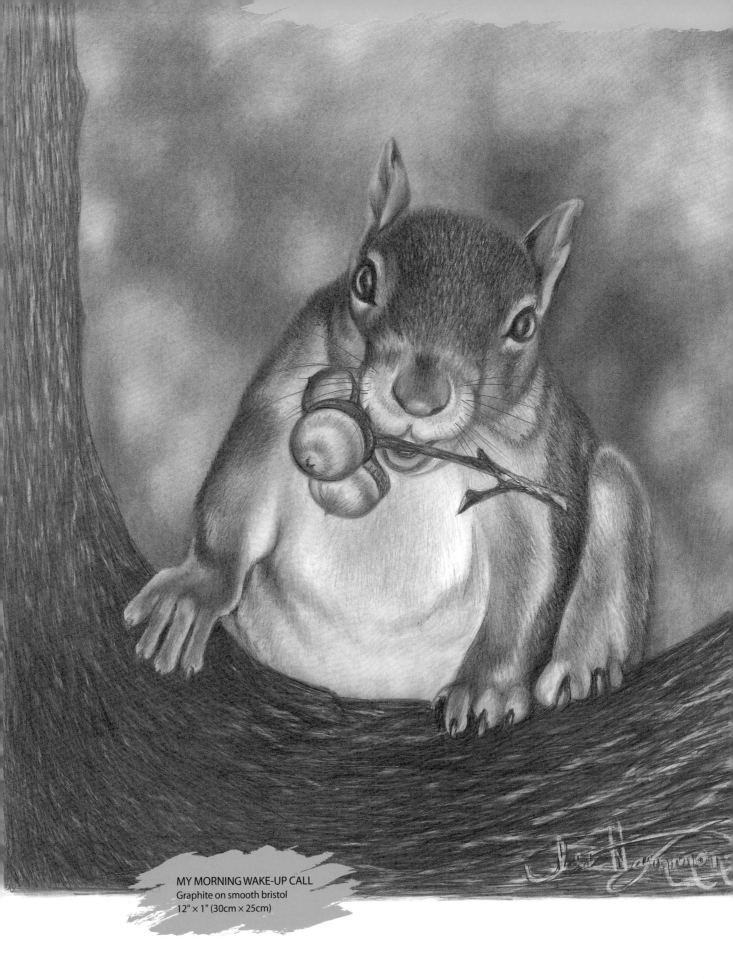

MY MORNING WAKE-UP CALL
Graphite on smooth bristol
12" × 1" (30cm × 25cm)

Receive free downloads when you sign up for our free newsletter at artistsnetwork.com/newsletters_thanks.

Eye and Ear

Draw the shapes of the ear and the eye. Create the short fur with small, quick pencil strokes All of the character of the squirrel is in the eye. The shine of the eye is very important, so lift it out with a kneaded eraser.

Acorns

These acorns are very much like the sphere exercise. Study the patterns of light and dark, and use blending to make them look round.

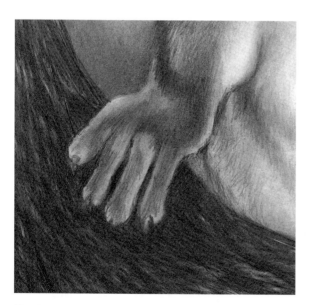

Feet

Each toe is a separate surface, which means light will reflect off the edges of each one.

Tree Bark

The texture of this tree was created by lifting the light out of the dark tones. Firm pencil lines created the look of ridges.

DRAW A FOX IN GRASS

Draw a fox in his natural setting using the step-by-step procedure. Use the grid method to capture the shapes on your drawing paper.

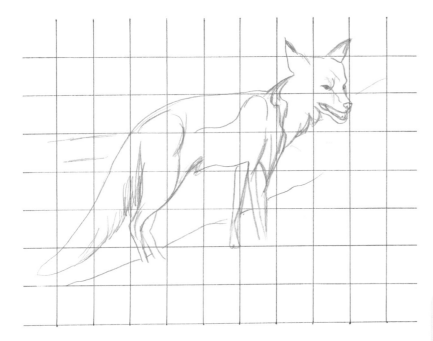

Materials

.5mm mechanical
 pencil with 2B lead

kneaded eraser

ruler

smooth bristol paper

tortillion

1 Use the Grid Method to Draw the Shapes

Use the grid method to draw the shapes one box at a time.

LEE'S LESSONS

Use only the kneaded eraser when removing grid lines. The other erasers may leave scuff marks that will show in your drawing, especially when you try to blend in those areas.

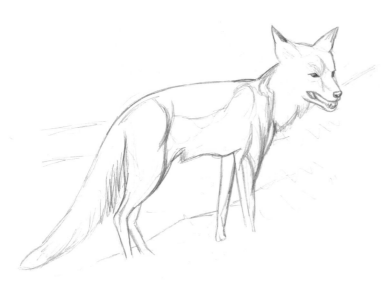

2 Remove the Grid

When you are sure of the accuracy of your drawing, carefully remove the grid lines with a kneaded eraser to reveal your line drawing.

Receive free downloads when you sign up for our free newsletter at artistsnetwork.com/newsletters_thanks.

3 Apply Light and Dark Patterns to Create Form

Apply the patterns of light and dark to the background. The direction of your pencil lines is important to creating the surfaces you are drawing. Make vertical lines to depict the grass. Make the lines under the fox horizontal to create the ground.

Apply the patterns of light and dark to the fox. Notice the reflected light along the back of the fox. Because of the light edges on the fox, place in the surrounding elements first. This allows the dark to create the light.

Once these patterns of light and dark have been created, you will see the form of the fox begin to stand out. Also note the cylinder shapes in the fox's body and legs.

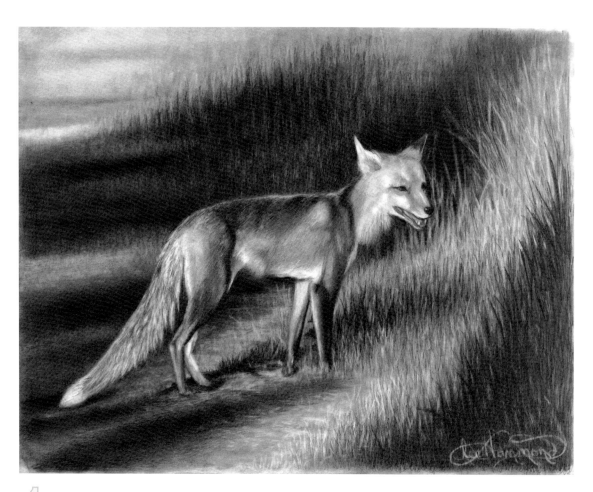

4 Build Up Tones and Textures

Finish the drawing by building the tones and textures with your pencil. Blend the tones out as you work and continue building on top. By blending, you lose the bright white of the paper, giving the drawing more depth.

Once the depth of tone is achieved, use a kneaded eraser to lift out the effects of sunlight. Use the eraser to lift the highlights out of the fox's fur as well. Keep building the tones until you achieve extreme contrast.

DRAW A WOLF IN FOGGY WOODS

The previous wolf was highly rendered and realistic. This one is less detailed, but the drawing is still intense. I call this a "mood drawing."

For this demonstration, begin with a simple line drawing. Try not to use the grid method unless you really need to. Rely on your freehand skills instead.

Materials

.5mm mechanical
 pencil with 2B lead

kneaded eraser

ruler

smooth bristol paper

tortillion

1 Create a Line Drawing

Draw the horizon line and the shape of the wolf. Then draw in vertical lines to represent tree trunks. Add some horizontal lines for the ground and the fallen trees on either side.

Don't be overly concerned about anything other than the wolf at this point. Its shape is the most important. If you need to, grid the wolf with an acetate grid overlay.

2 Create Tones

Begin blocking in the tones. Start with the darkest areas first, filling in the fallen tree trunks. Because they are the darkest part of the drawing, they will give you something to compare against.

Using horizontal lines, start building the dark tones at the bottom of the drawing and work up to create the illusion of water. Add the mirror image reflections in the water area, directly below the standing trees.

Using vertical strokes, fill in the tree trunks and add some limbs. Add more vertical lines to the grassy area along the horizon line. Place some vertical lines up top as well to represent the background. Leave the center area white for now.

Because the light comes from the top, add a shadow to the bottom portion of the wolf. Use the blending technique on the rest of the drawing. Start at the top and blend the foliage area of the trees into a smooth gray tone. This begins to create the look of a foggy scene.

3 Finish

Finishing this drawing will require lots of blending and lots of patience! This is when persistence is really going to pay off. While the drawing might look complicated, it's not. It is just time-consuming and simply a matter of adding tones and blending them in. Start at the top and work down, using the following guidelines:

Background

Blend more gray tones into the background in the upper corners. Use a circular stroke to represent foliage. Deepen the darkness of the tree trunks on the left. Add the branches and little dark clumps to represent leaves. Making them dark against the blending gives the illusion of distance. Blend the tones on the wolf, making them go from dark to light. They should be lightest on the top.

Midground

Blend out the water with horizontal strokes until the water looks smooth. Reapply the dark tones into the shadow areas and blend again. Add the grass into the shadow area. Lift the streaks of light out of the water with a kneaded eraser. Lift the light off the tops of the fallen trees with a Tuff Stuff eraser.

Foreground

Darken the water once more with the pencil and horizontal strokes. Reblend this area to make it smooth. Like the water above, lift the horizontal highlights with the kneaded eraser. Add the dark grass and reeds into the lower corners using firm strokes with the pencil. Add highlights to the reeds with the Tuff Stuff eraser.

Sun Rays

Add the sun rays using a kneaded eraser. Do not pinch it into a small point like you would for thin lines. Use a larger piece. Sun rays always radiate out like the spokes in a wagon wheel. Make them straight and do not bend. They should look transparent, with the object still visible through them. If you take out too much, and it becomes too light, just blend into it to tone it down.

LEE'S LESSONS

The Tuff Stuff eraser is great for lifting out bright white, distinct marks. It creates harder edges than the kneaded eraser. I even used it to put my signature into this drawing!

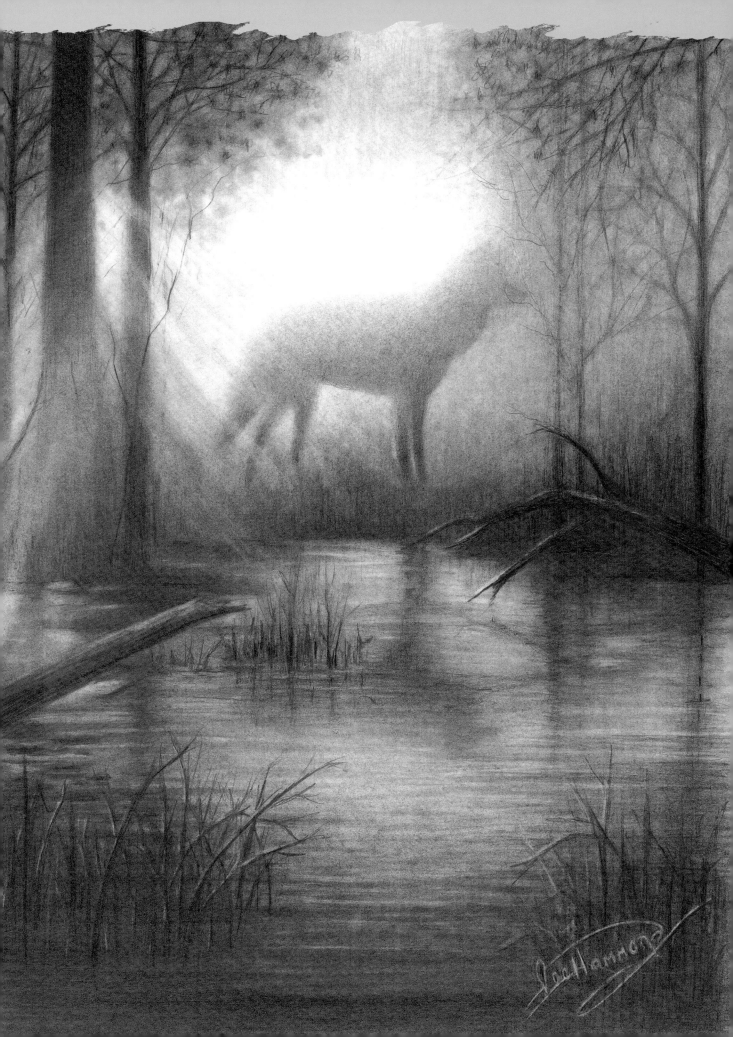

DRAW A LILY FROG

There are many details to capture in this drawing, and the close-up view exaggerates them even further.

Materials

.5mm mechanical
 pencil with 2B lead

kneaded eraser

ruler

smooth bristol paper

tortillion

1 Grid the Flower and Frog
Use the grid method to draw the flower and the frog. Draw what you see one box at a time. Because this is a close-up, there are many lines and lots of details to capture. Go slowly and be as accurate as possible.

2 Remove the Grid Lines

When you are sure of the accuracy of your drawing, carefully remove the grid lines from your paper with a kneaded eraser. This is what your accurate line drawing should look like. Do not start adding any tones until you have this drawing right.

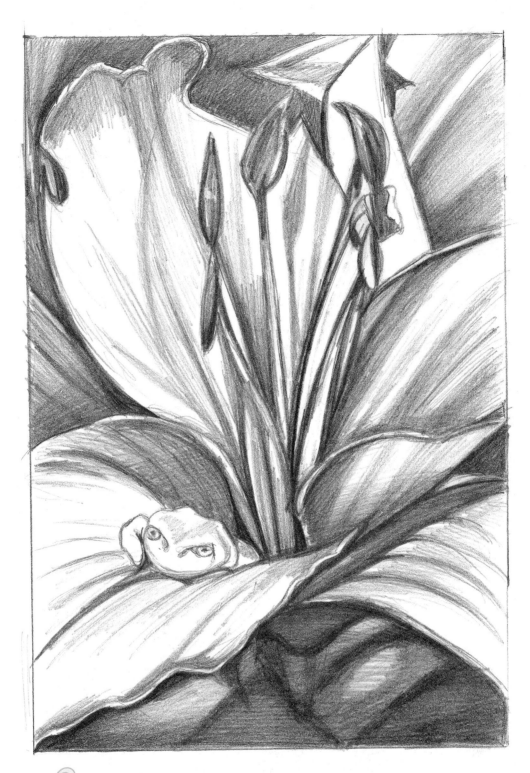

3 Block In the Shapes

This stage of the drawing can get confusing, so pay close attention to the example. There are many overlapping shapes and subsequent shadows. I call this the "blocking in stage."

Fill in the darkest areas of the drawing with your pencil. Study this example closely, and lay in the shapes like a puzzle. Pay attention to the direction of the pencil lines—they help create the curve of the flower petals.

Receive free downloads when you sign up for our free newsletter at artistsnetwork.com/newsletters_thanks.

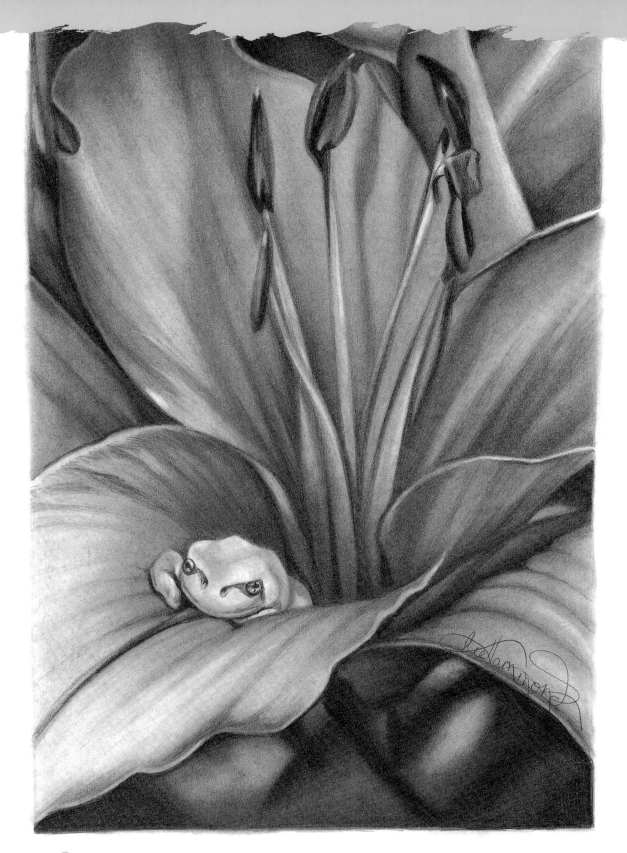

Blend Out the Tones

Blend out the tones so everything looks smooth. Because of the overlapping petals and surfaces, there is a lot of reflected light along the edges. There is also light along the edges of the stamens.

Study the darker areas. It is important to use these dark areas to help create the recessed areas of the flower and to create the shadows. Notice the cast shadows of the stamens on the petals.

The frog is made up of mostly shading. He actually resembles a sphere with a face on it.

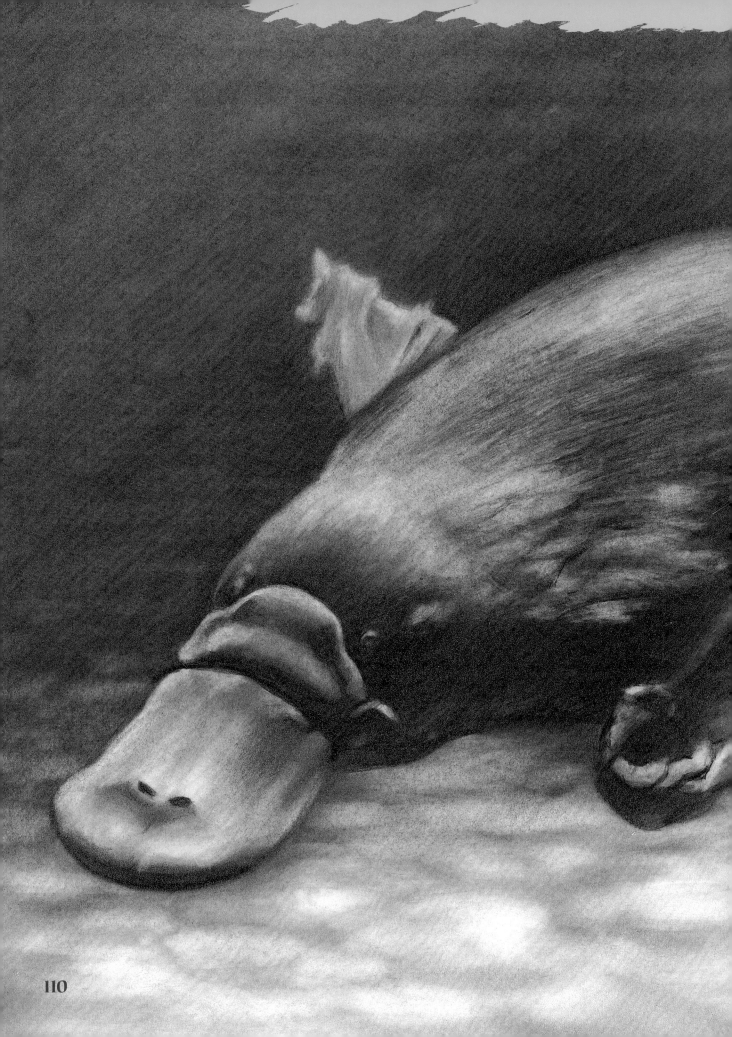

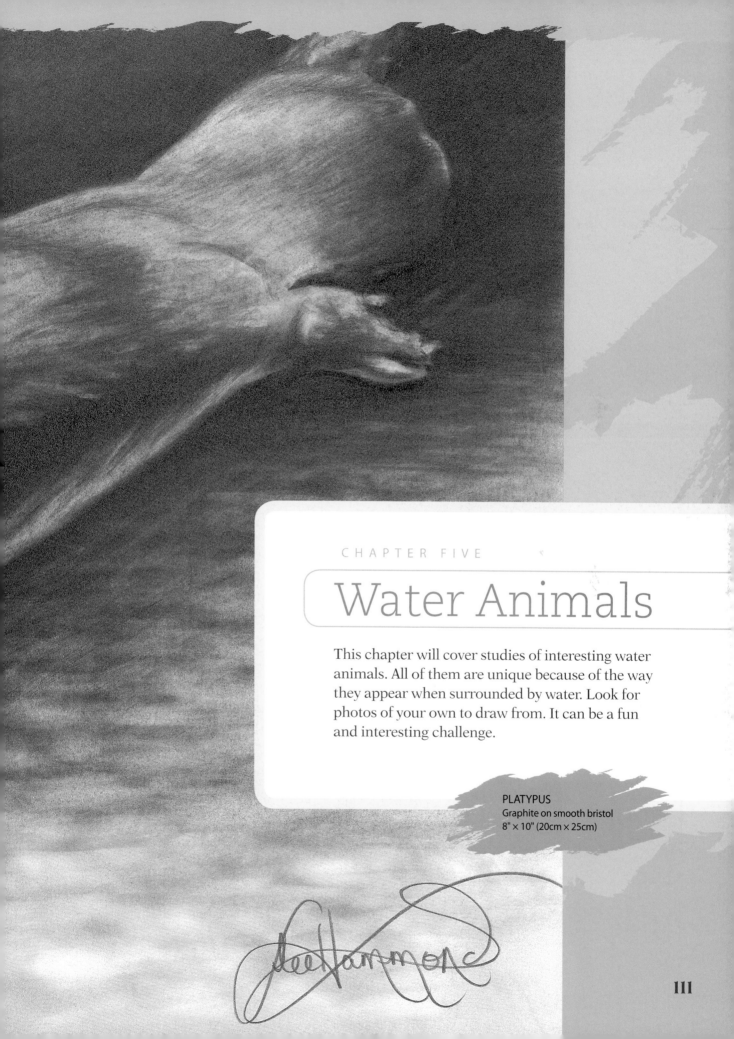

Water Animals

This chapter will cover studies of interesting water animals. All of them are unique because of the way they appear when surrounded by water. Look for photos of your own to draw from. It can be a fun and interesting challenge.

PLATYPUS
Graphite on smooth bristol
8" × 10" (20cm × 25cm)

Aquatic Settings

Each of these drawings can be divided into two categories: the animal and the water. Both are extremely important. You must be able to depict water realistically in for the drawing to work.

Water Breaks Up Shapes

At first glance this looks like an abstract drawing. But closer inspection reveals the koi swimming in the water. The shapes and patterns created are fun to look at.

The interesting light dancing off the water was created with the Tuff Stuff eraser.

KOI POND
Graphite on smooth bristol
11" × 14" (28cm × 36cm)

Learn to See Light Patterns

Although the hippo is a fun subject, it is the ripples in the water that catch the eye. You can feel the movement of the water in the way the light has been lifted.

Water moves in specific patterns and is illustrated with light and dark. Once you learn to see those patterns, you can draw realistic water. I carefully studied my photo reference to make sure I captured the patterns of light and dark accurately.

SMILING HIPPO
Graphite on smooth bristol
11" × 14" (28cm × 36cm)

Receive free downloads when you sign up for our free newsletter at artistsnetwork.com/newsletters_thanks.

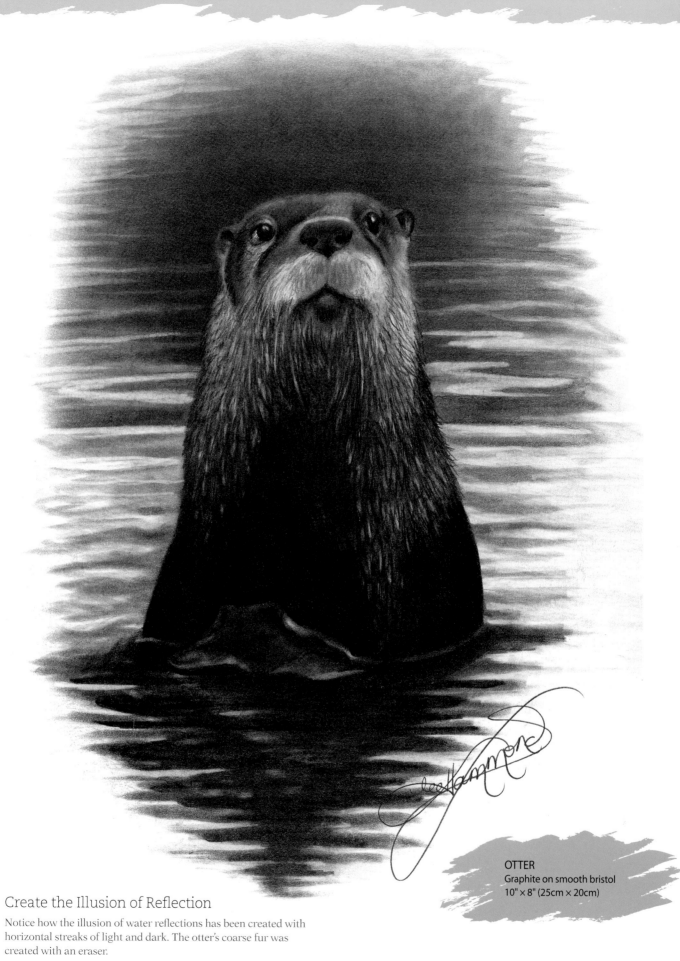

OTTER
Graphite on smooth bristol
10" × 8" (25cm × 20cm)

Create the Illusion of Reflection

Notice how the illusion of water reflections has been created with horizontal streaks of light and dark. The otter's coarse fur was created with an eraser.

Get a bonus demonstration from *Amazing Crayon Drawing with Lee Hammond* at artistsnetwork.com/drawanimalsinnature.

DRAW DOLPHINS

Follow along to draw this pair of dolphins.

Materials

.5mm mechanical
pencil with 2B lead

kneaded eraser

ruler

smooth bristol paper

tortillion

1 Grid the Dolphins
Use the grid method for drawing the shapes of the dolphins. Lightly draw the squares on your drawing paper. Then draw what you see, one box at a time.

LEE'S LESSONS

With a drawing like this, it is important to not give up too soon. Go slowly when adding the tones to keep them even. When blending, take your time to keep the tones smooth. When lifting, take your time so the marks you make are delicate. It is worth the effort.

2 Remove the Grid
When you are sure all of the shapes are accurate, carefully erase the grid lines with a kneaded eraser.

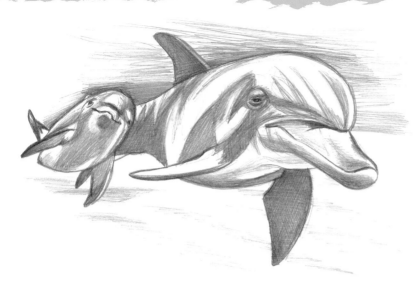

3 Capture the Patterns

Because of the way the water affects the lighting, there are distinct patterns of light and dark to capture.

Fill in the darkest shapes of the dolphins as shown. The darkest areas are in the fins and the shadow areas on their bodies.

The light is reflecting off the bottom of the ocean, making the upper portion of the drawing darker than the rest. Apply the darkness above and behind the dolphins to make the light appear to bounce off their skin. Apply these tones using horizontal strokes to match the movement of water.

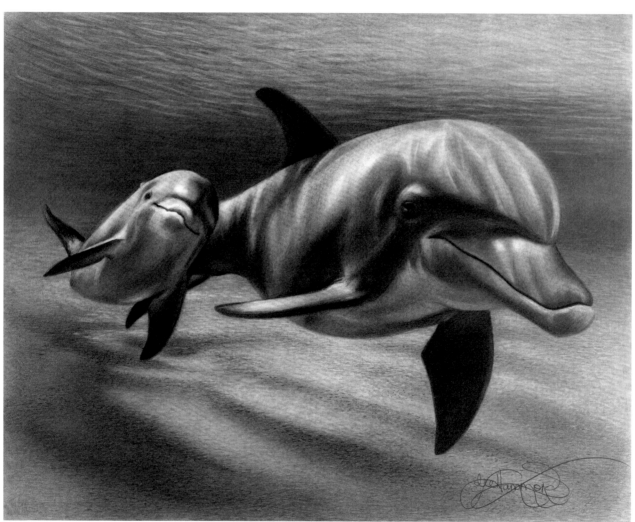

4 Blend and Lift Out to Finish

Focus on the dolphins' form, blending the contours. Lift out the water with a kneaded eraser using quick horizontal strokes. Make it lightest toward the upper right corner. Lift out the lighting on the dolphins using a kneaded eraser.

Create the look of the sandy ocean bottom with a kneaded eraser. Apply short pencil strokes for the darker areas to create the shadowy effect. Blend everything repeatedly to keep the tones soft and keep the pencil strokes from looking too harsh.

Segment Drawing

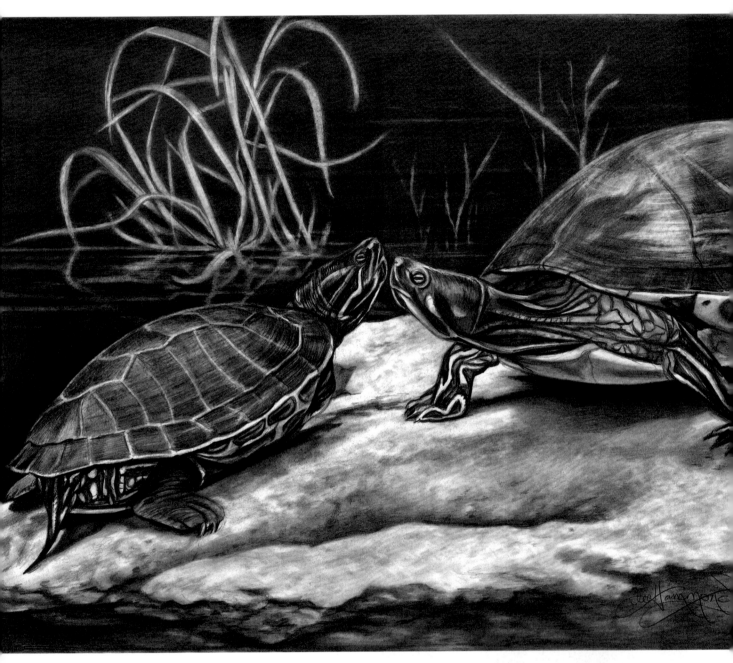

Tone and Contrast Help Define Focal Points

This drawing is an exercise in extreme darkness. The tones surrounding the turtles make the turtles the focal point. Good contrasts can make for awesome drawings.

BASKING IN THE SUNLIGHT
Graphite on smooth bristol
11" × 14" (28cm × 36cm)

Receive free downloads when you sign up for our free newsletter at artistsnetwork.com/newsletters_thanks.

Turtle Shell

Viewed in this small square, this turtle shell looks like just a group of random shapes. Drawing these small segments makes you concentrate on patterns and tones.

In this segment you must see the details within the details. The shapes are dark against light, but there are small details within the shapes. Look closely and you can see the small striations in the shell, which were created with delicate pencil lines and gentle lifting with a kneaded eraser.

Rocks

Creating the look of these rocks is fairly simple. Start with the basic shapes within the segment. Apply the darkest areas first with the pencil and blend it out. Lift the lighter tones out with the kneaded eraser.

Plants and Reflections

The shapes of the plants were drawn in first, then the very dark tones were added with firm pressure on the pencil. To make things look smoother, I blended everything and then reapplied the dark tones once more. The reflections were lifted out with the Tuff Stuff eraser. If you look closely, you can see a horizontal dividing line representing the surface of the water. It separates the actual plant from the reflection.

Birds

Drawing birds is a fun challenge. Some find it difficult, saying birds are so different than drawing animals. I disagree. It is just the way we think about them that makes it difficult. Instead of over-thinking it and becoming overwhelmed by all of the feathers, think of birds like everything else—in terms of shapes, lights and darks.

COCKATOO
Graphite on smooth bristol
14" × 11" (36cm × 28cm)

SEAGULL AT SUNSET
Graphite on smooth bristol
14" × 11" (36cm × 28cm)

Scenery Helps Set the Mood

Placing a bird in its natural surroundings makes for
wonderful art. This seagull in flight is a perfect example.
Study this example for all of the elements we have studied.
Look at the waves, the way the reflected light dances off each
wave and how it was lifted. You can see the same procedure
on the edges of the seagull's wings.

LEE'S LESSONS

*Always look for the basic shapes in your
subject matter. Use lighting to help create
the mood of your drawing.*

Receive free downloads when you sign up for our free newsletter at artistsnetwork.com/newsletters_thanks.

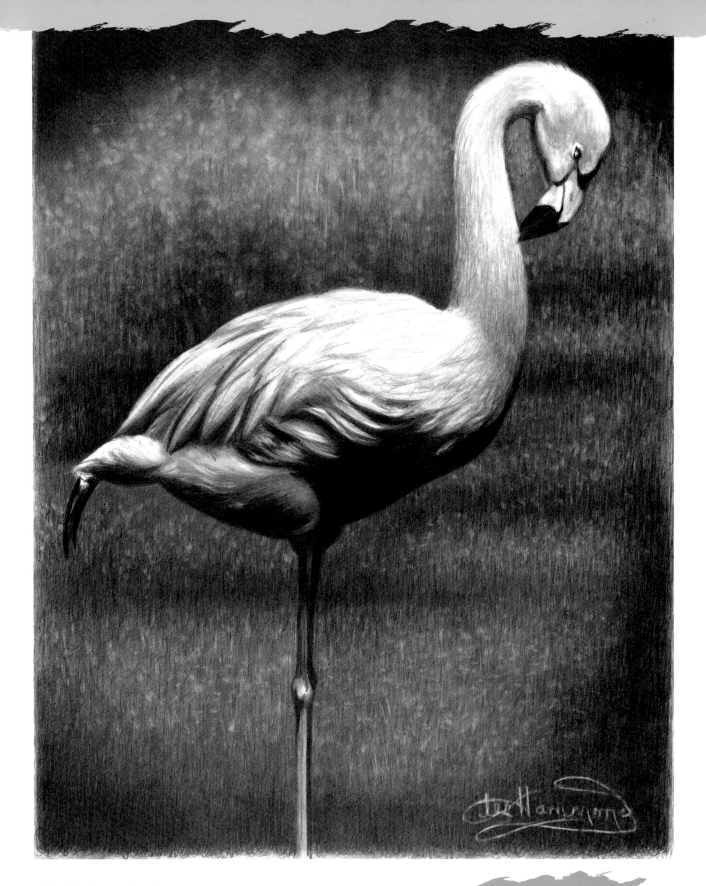

It's All About the Contrasts

The lighting in this example is extreme, and it makes the drawing look bold. The extreme contrast of light and dark illuminates the shape of the flamingo. It is easy to see the egg shape in the body and head, and the cylinder in the neck and legs.

FLAMINGO
Graphite on smooth bristol
14" × 11" (36cm × 28cm)

DRAW A DOVE

As with anything else, you can make it as easy or as complicated as you like. Drawing birds is no exception. This little drawing of a dove will get you started drawing birds.

Materials

.5mm mechanical
 pencil with 2B lead

kneaded eraser

ruler

smooth bristol paper

tortillion

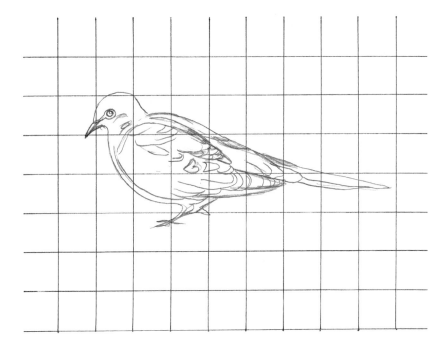

1 Grid the Dove
Use the grid method to draw the shapes of the dove. Lightly draw the grid lines on your drawing paper, and draw what you see within each box.

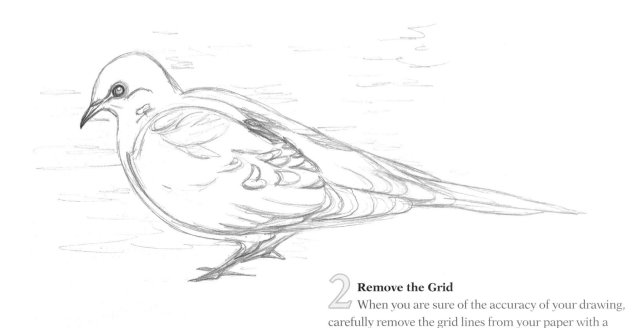

2 Remove the Grid
When you are sure of the accuracy of your drawing, carefully remove the grid lines from your paper with a kneaded eraser.

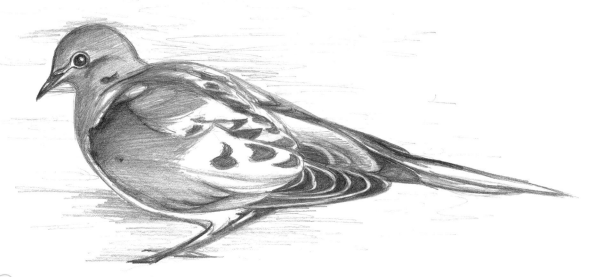

3 Draw the Patterns and Begin the Background

Carefully draw in the patterns in the feathers of the dove. The feathers at the front of the bird should be very smooth, while the feathers in the back should be more distinct. Give each feather in the back a light edge around it. Start to apply some lines in the background using horizontal strokes.

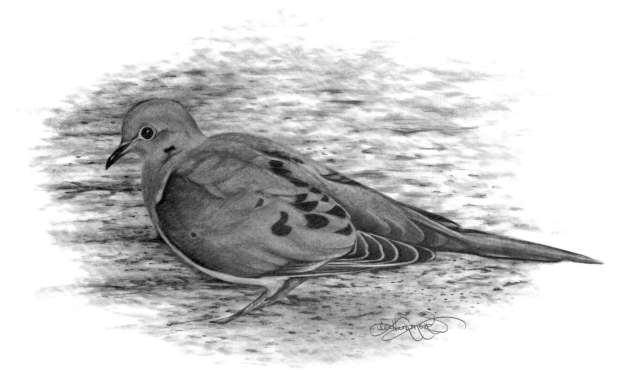

4 Blend Out and Finish the Background

Blend out the entire dove until it is a medium gray tone. With a kneaded eraser, carefully lift out the subtle light areas in the head and the body. These lighter tones make the roundness of the bird more pronounced. Pay particular attention to the reflected light along the edges of the feathers and wings.

To finish the background, create the illusion of the ground. Because it is rough with little rocks and shadows, you must use a combination of light and dark to produce it. Create random patterns of light and dark, and blend them all out. Use firm pressure with the pencil to create little spots that resemble rocks. With a kneaded eraser, lift out areas of light to make the ground look speckled. Notice a slight cast shadow under the dove and on the left side. Make this area darker.

DRAW A SWAN

Use the grid method to draw this swan.

1 Grid the Swan

Use the grid to capture the shapes of the swan and its reflection. Lightly draw a grid on your drawing paper, and draw in the shapes one box at a time. View the shapes as puzzle pieces.

2 Remove the Grid

When you are sure your shapes are accurate, carefully remove the grid lines from your paper using a kneaded eraser.

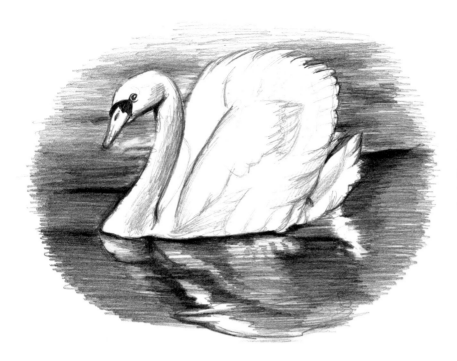

3 Add Tones

Draw in the tones as shown. Notice the direction the lines are going. In the background and in the water they are going horizontally. On the bird they follow the contours.

4 Blend and Lift Out to Finish

Blend the entire drawing out with a tortillion, making the tones look smooth. Make the water area a bit darker than the background above.

Use a kneaded eraser to lift the light areas out of the swan. This is what creates the illusion of feathers. It is also used in the background to create the texture and illusion of a rocky ledge.

Study the contours of the swan and remember the five elements of shading as you go. Look for cast shadows. You can see them to the right of the neck and on the tail feathers.

When lifting the light out of the water area, use horizontal swipes with the kneaded eraser. This helps create the movement of the water.

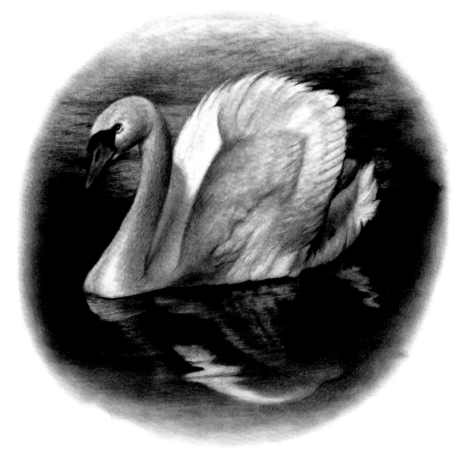

DRAW DETAILED FEATHERS

When looking at feathers closely, you can see they resemble shingles in the way they overlap each other in layers. They appear in many sizes, colors and patterns, so study well. For some practice on drawing detailed feathers, begin with segment drawing.

Materials

.5mm mechanical
 pencil with 2B lead

kneaded eraser

ruler

smooth bristol paper

tortillion

1 Start With the Square
Start with your two-inch (51mm) square. Draw in the shingle-like shapes of the feathers. Add some patterns as shown.

2 Blend and Lift the Tones
Blend out the tones with a tortillion. Reapply the dark tones under each feather. Deepen the patterns and blend again. Lift the light areas out with the kneaded eraser.

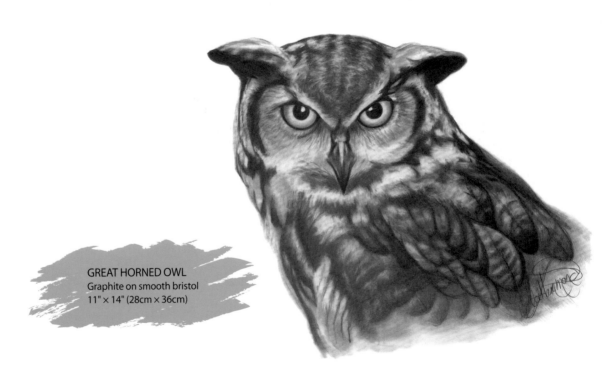

GREAT HORNED OWL
Graphite on smooth bristol
11" × 14" (28cm × 36cm)

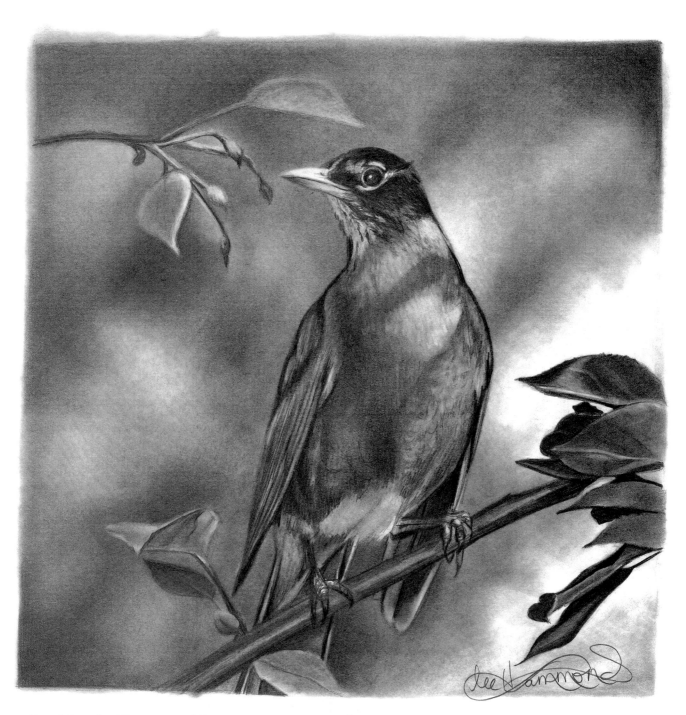

Combine the Elements of Nature Into Your Drawing

The background has a heavily blended appearance with subtle light and dark patterns, which create the illusion of sky. Everything in the foreground looks crisp and in focus, while the small sprig of leaves in the upper left has less detail. One of the things I love most about this drawing is the highlight and shadow on the breast of the bird. This gives the drawing a look of authentic sunlight and realism.

ROBBY
Graphite on smooth Bristol
11" × 14" (28cm × 36cm)

Segment Drawing

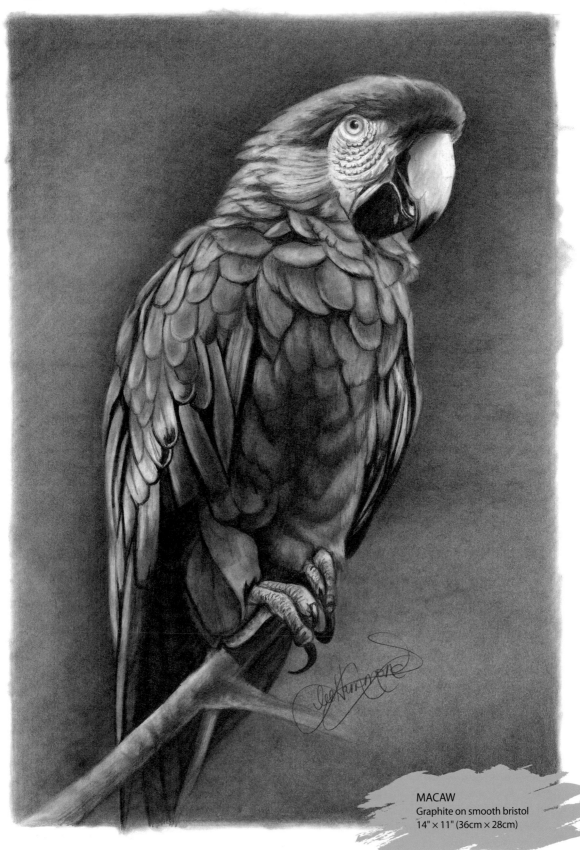

MACAW
Graphite on smooth bristol
14" × 11" (36cm × 28cm)

Face and Beak

This area contains extreme contrasts in texture and tone. The beak is very smooth and shiny, and it contains all the tones ranging from black to white.

The eye is shiny, but the area around the eye is extremely rough and textured. This was created with dark pencil lines in a scalloped design. The area was lightly blended and then the light was lifted above the squiggly lines to make the area look raised.

Feet

This area closely resembles the texture seen in some of the other animals we have covered. It looks a lot like the skin of the elephants and the rough texture on the turtle. Again, it is all about the contrast of light and dark, and the proper use of the pencil lines to create a texturized appearance.

Feathers

The feathers overlap like shingles. Because the surfaces overlap, you see a shadow below and reflected light along the edges. The tone in the background helps give the illusion of light reflecting off the surface of the bird.

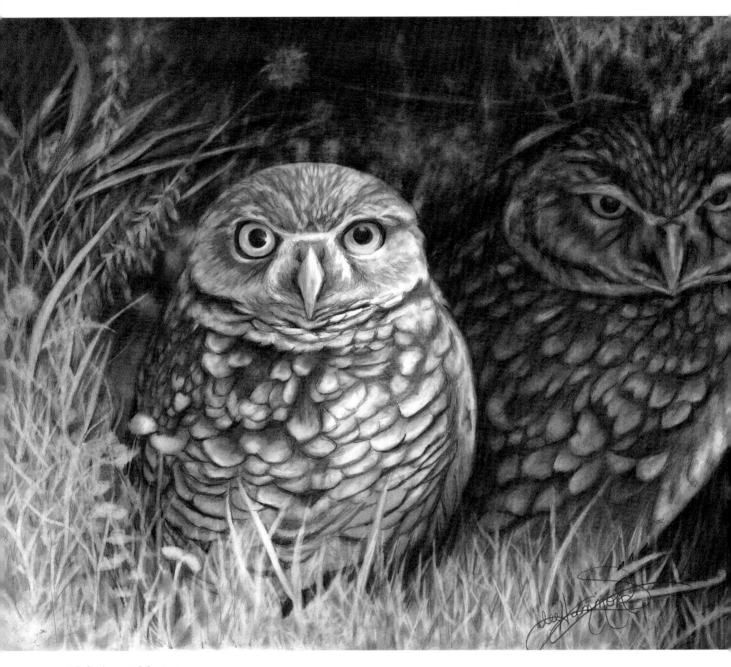

Lighting Adds Interest

This piece has some interesting lighting with one owl being the focus and the other in the shadows. Lighting like this keeps a drawing from looking ordinary and boring.

BURROWING OWLS OF MARCO ISLAND
Graphite on smooth bristol
11" x 14" (28cm x 36cm)

Receive free downloads when you sign up for our free newsletter at artistsnetwork.com/newsletters_thanks.

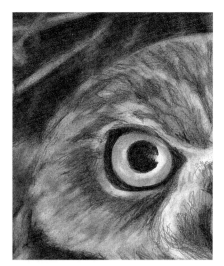

Eye

This is a study of contrasting tones and textures. The eye appears very shiny due to blending and the lifting of the highlights on top and to the right. The area surrounding the eye looks textured due to the pencil lines. This creates the look of small feathers.

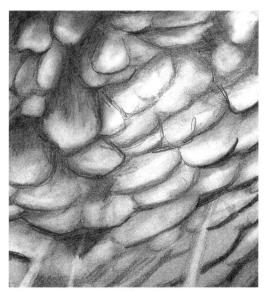

Feathers

The feathers look like overlapping shingles. There is always darkness below each feather and light along the outer edge.

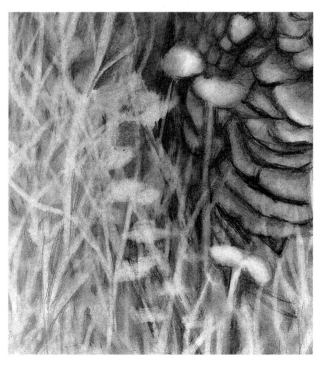

Grass and Reeds

This area is an illusion of grass and reeds. Because it is closer than the owls, and the owls are the main focus, the reeds appear somewhat blurred with less detail. I created them with the Tuff Stuff eraser by erasing the light shapes out of the darker tones already drawn in.

Gallery

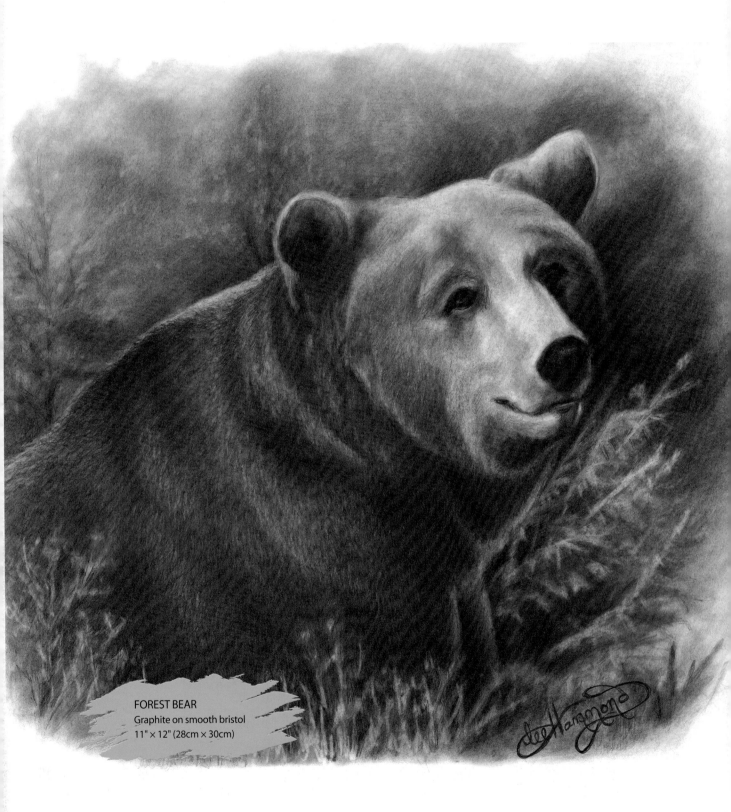

FOREST BEAR
Graphite on smooth bristol
11" × 12" (28cm × 30cm)

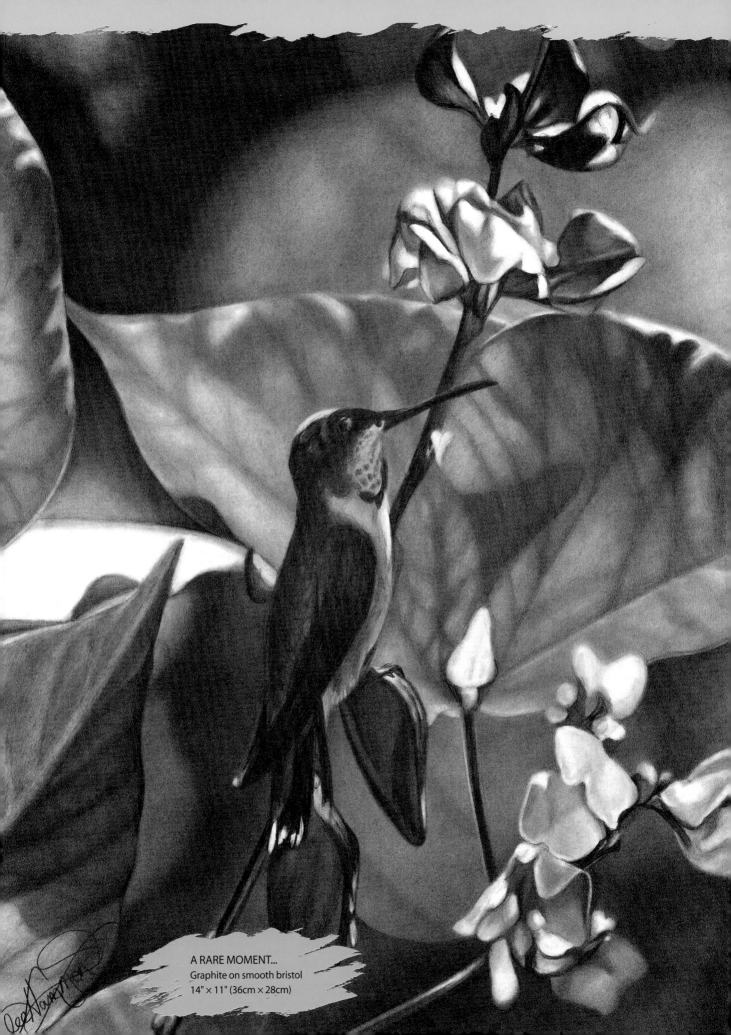

A RARE MOMENT...
Graphite on smooth bristol
14" × 11" (36cm × 28cm)

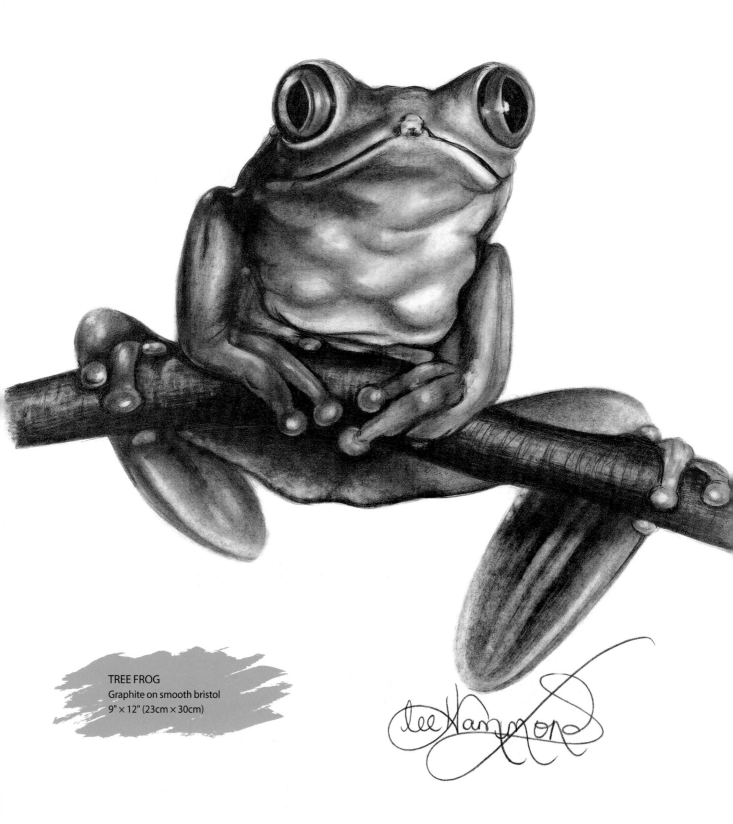

TREE FROG
Graphite on smooth bristol
9" × 12" (23cm × 30cm)

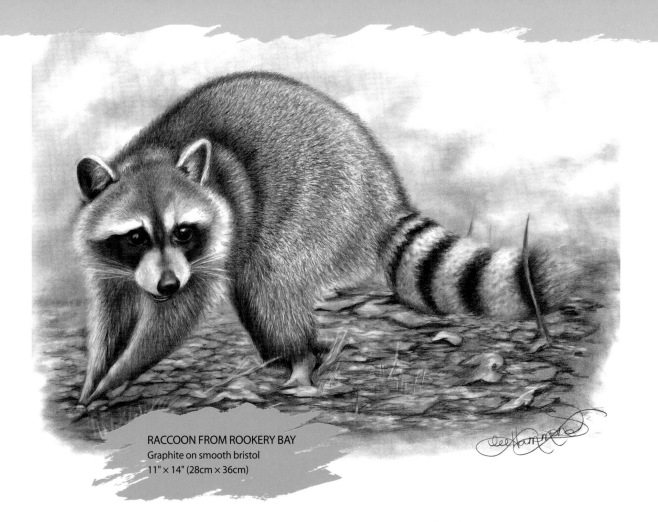

RACCOON FROM ROOKERY BAY
Graphite on smooth bristol
11" × 14" (28cm × 36cm)

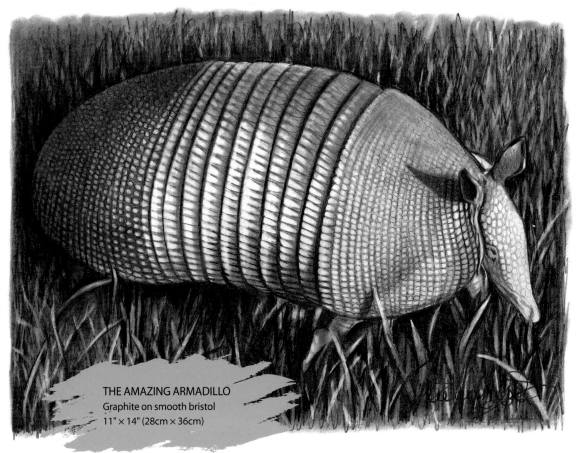

THE AMAZING ARMADILLO
Graphite on smooth bristol
11" × 14" (28cm × 36cm)

Get a bonus demonstration from *Amazing Crayon Drawing with Lee Hammond* at artistsnetwork.com/drawanimalsinnature.

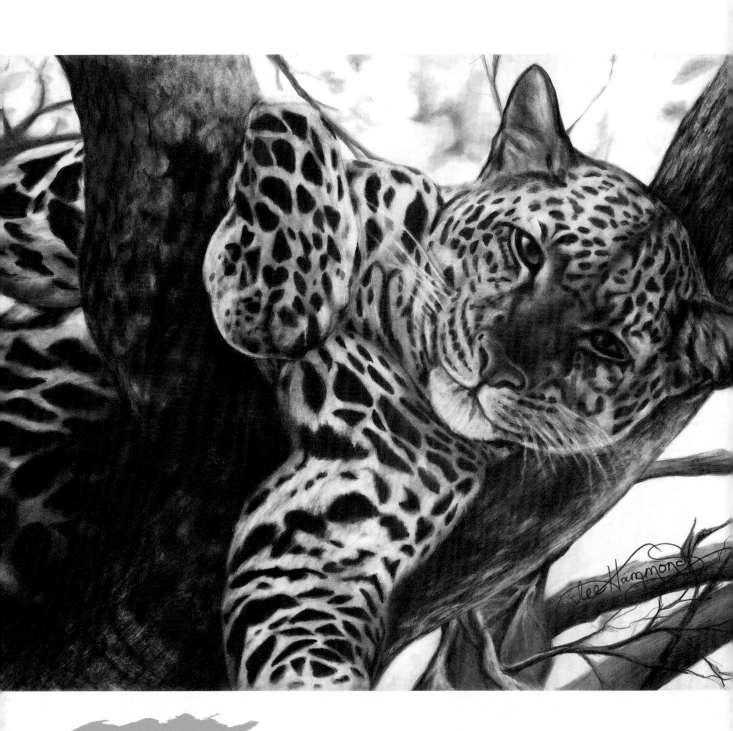

LEOPARD IN TREE
Graphite on smooth bristol
11" × 14" (28cm × 36cm)

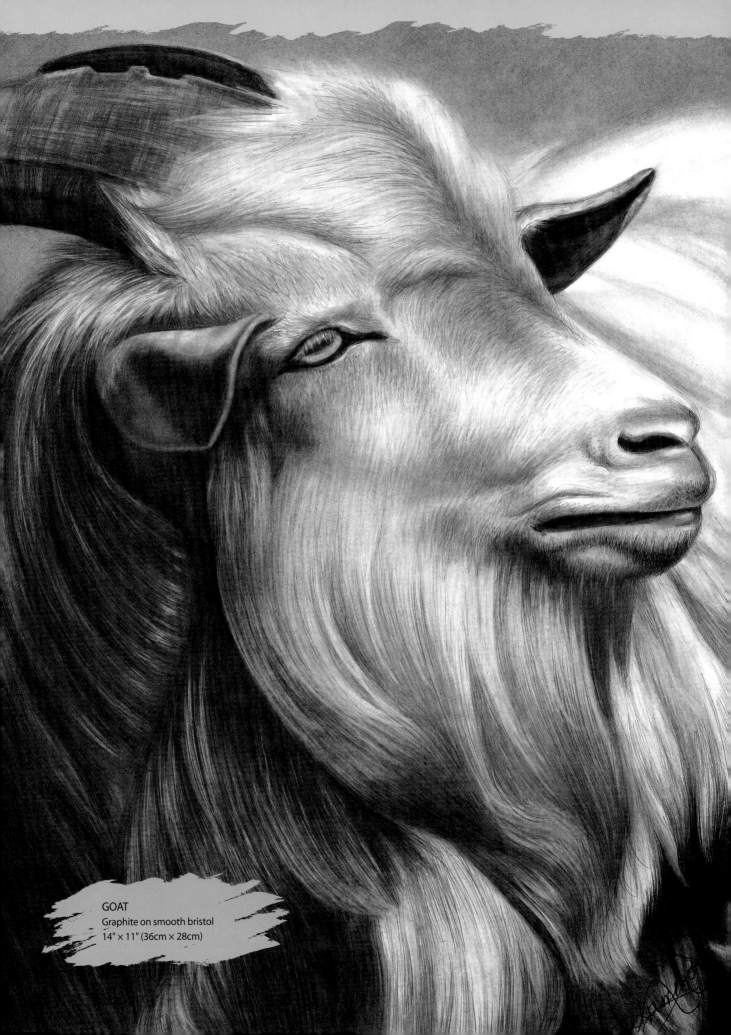

GOAT
Graphite on smooth bristol
14" × 11" (36cm × 28cm)

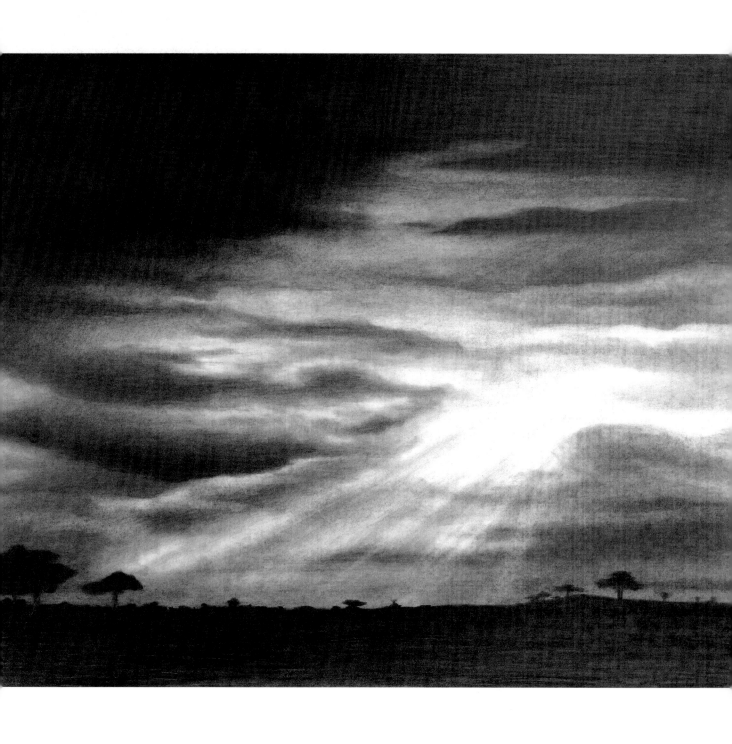

Conclusion

Every time I come to the end of a book, I feel the same way—I wish I could go further. I wish I could do more. Never have I felt that sentiment more than with this book. I love wildlife illustration!

I have a banner in my studio with a favorite quote I came up with: "There is never a lack of subject matter, just absence of creativity." (Think about it!) Everything I look at has artistic possibility for me. Every time I turn around, it seems something is begging to be drawn. I have literally thousands of photo references waiting for me, and I keep taking more. If this is the definition of artistic obsession, I hope to never be cured!

I feel like the luckiest person in the world to be this obsessed with something so fun and to be able to make a living at it! No one said it would be easy though, and it really hasn't been. I have worked tirelessly to achieve my goals. It has taken years and years to hone my skills.

Hopefully you have gained valuable information from this book. I hope it inspires you to practice as much as I do. If you do, I know you will succeed. It will not always be easy, nor will it always be fun, but it will always be rewarding.

Thank you for allowing me to mentor you. I wish you all the luck in the world, and may the artistic obsession that I so love and enjoy take over in you as well!

Your friend,

Get a bonus demonstration from *Amazing Crayon Drawings* at artistsnetwork.com/drawanimalsinnature.

139

Index

Get a bonus demonstration from *Amazing Crayon Drawing with Lee Hammond* at artistsnetwork.com/drawanimalsinnature.

141

ABOUT THE AUTHOR

A professional artist/instructor for more than thirty years, Lee Hammond has authored or appeared in over fifty North Light books, DVDs, CDs, eBooks, downloads and streaming videos. She owned and operated the Midwest School of Art in Lenexa, Kansas, and now owns a private studio in Overland Park, Kansas, where she teaches full time during the warm months. In the winter, she resides in Naples, Florida and teaches art classes at the Rookery Bay Research Reserve. She conducts drawing and painting seminars, gives school lectures and mentors nationwide. Lee is a certified police composite and forensic artist and is on call for the Kansas City and SW Florida police departments. She has worked with America's Most Wanted and other crime shows and documentaries on Court TV, Tru TV and the Travel Channel. A former contributing writer for The Artist's Magazine, she was also a licensed illustrator for many of the NASCAR drivers and teams. Her current artistic pursuits include illustrating the many children's books she has written and completing a motivational book and a novel. See more of Lee's artwork on her website at LeeHammond.com.

Other fine North Light Books are available from your favorite bookstore, art supply store or online supplier. Visit our website at fwmedia.com.

16 15 5 4 3

DISTRIBUTED IN CANADA BY FRASER DIRECT
100 Armstrong Avenue
Georgetown, ON, Canada L7G 5S4
Tel: (905) 877-4411

DISTRIBUTED IN THE U.K. AND EUROPE
BY F&W MEDIA INTERNATIONAL
LTD Brunel House, Forde Close, Newton Abbot, TQ12 4PU, UK
Tel: (+44) 1626 323200, Fax: (+44) 1626 323319
Email: enquiries@fwmedia.com

DISTRIBUTED IN AUSTRALIA BY CAPRICORN LINK
P.O. Box 704, S. Windsor NSW, 2756 Australia
Tel: (02) 4577-3555

Edited by Christina Richards
Designed by Kelly O'Dell
Production coordinated by Mark Griffin

METRIC CONVERSION CHART

To convert	to	multiply by
Inches	Centimeters	2.54
Centimeters	Inches	0.4
Feet	Centimeters	30.5
Centimeters	Feet	0.03
Yards	Meters	0.9
Meters	Yards	1.1

ACKNOWLEDGMENTS

Writing a book is certainly no easy task. Over fifteen years ago, I was assigned an editor for my very first book. I was a nervous wreck, afraid of every typo. (Back then, we did it on a typewriter!) My editor's name was Kathy Kipp, and she helped me create one of North Light's most popular books, *How to Draw Lifelike Portraits From Photographs*. I was overwhelmed by the process back then, but she took my hand and paved the way.

Through the years and the many books I've written since, one thing stayed the same. Every book I did for North Light did well due to their amazing professionalism. And every book I wrote with Kathy Kipp as my editor became a great seller. Kathy has finally taken a much-deserved retirement, and I want this book to honor her. Without her help and guidance, none of this would exist. We made a great team, and the readers always reaped the benefits.

This book will be no less great, however, now that my editor is Christina Richards. We have worked together on a previous book, *Amazing Crayon Drawing*, and it turned out wonderful. Thank you for your help on this one, Christina! I am sure it will turn out amazing as well!

I hope my readers and fans will enjoy this new book for many years to come. It was a pleasure writing it! I think you will see what more than thirty years of practice has done for me reflected in the art showcased within this book. The same can happen for you!

I realize that without the support of a huge fan base, even the best of books will not do well. I am blessed with the most passionate fans in the world! Because of you, I know this one will do well too!

Thank you!

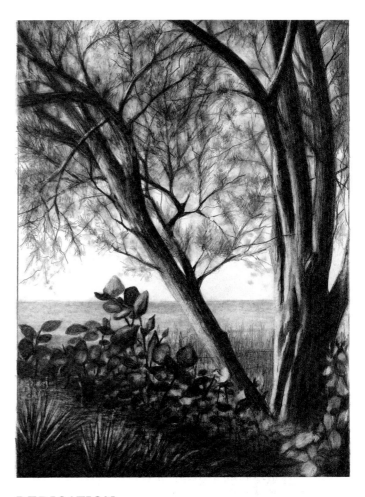

DEDICATION

This book is dedicated to my dear friend Laura Tiedt. Looking over my writing career that began back in the early 1990s, one thing has always been constant—Laura's friendship and never-ending encouragement. During those years I produced a wide variety of art books and maintained a thriving art business. I've had more adventures than most even think about. But I also faced many of life's challenges, including divorce, heartache, the death of friends and family and my own personal illness. Without the unwavering love and kindness (and sometimes a couch to sleep on) Laura provided me, I am sure I would have faltered. "Thank you" does not nearly cover my depth of gratitude. Here's to many more years of friendship, Laura—and I am sure, many more wonderful adventures.

Ideas. Instruction. Inspiration.

These and other fine North Light products are available at your favorite art & craft retailer, bookstore or online supplier. Visit our websites at artistsnetwork.com and artistsnetwork.tv.

Follow North Light Books for the latest news, free wallpapers, free demos and chances to win FREE BOOKS!

Follow us!

VISIT ARTISTSNETWORK.COM AND GET JEN'S NORTH LIGHT PICKS!

Get free step-by-step demonstrations along with reviews of the latest books, videos and downloads from Jennifer Lepore, Senior Editor and Online Education Manager at North Light Books.